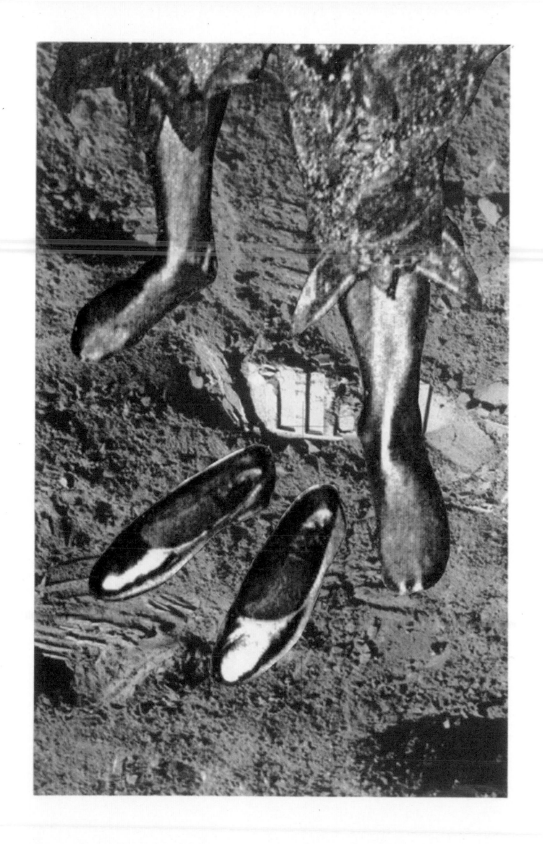

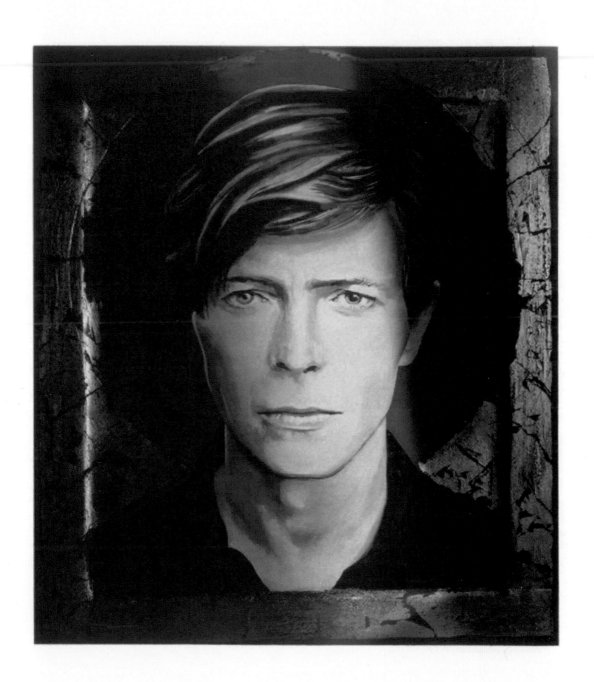

'Unmade Up…

Recollections of a friendship with David Bowie by Edward Bell

An anecdotal narrative of a sometime friendship
founded upon a visually creative collaboration, from
'Scary Monsters' 1980 to 'Tin Machine II' 1991.

Illustrated with original artwork
and many photographs never before published.

UNICORN

Dedicated to the Memory
of
David Robert Jones
1947 – 2016

His presence was strongly felt as what follows was written.
He said once that he'd done everything except write a book.
It is as if, only now, in death, he has finally
fulfilled his ambition and become,
in more than one sense of the word,
a ghost writer.

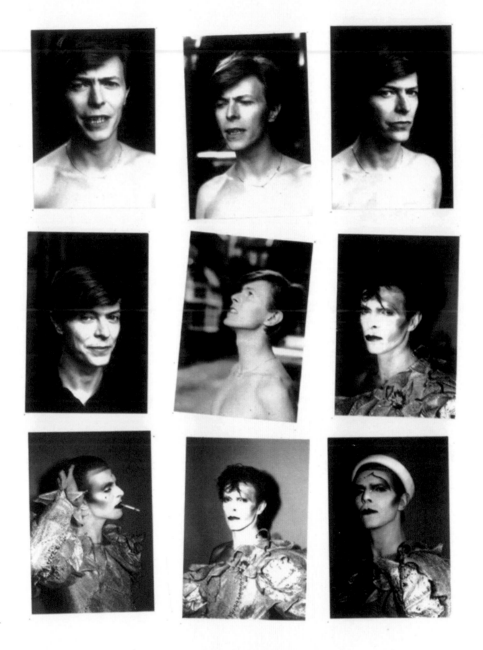

1980 : Mask and no mask
Before and after the 'Scary Monsters' photo session.

Preface

David Bowie: He soared, his eagle eye spied everything. His magpie nature urged him to plunder with ruthless perception. The Chameleon absorbed, then radiated, colours eclipsing. A butterfly mind, alighting, random and eclectic. Courageous, enigmatic, outrageous, and contradictory, he was Star Man, Elephant Man, a Diamond Dog, Tin Machine, the mythological peacock of incorruptible flesh.

David Bowie wasn't just the maker of music; he became the transcendent oracle and style icon of youth universal. With a raptor's eye for the innocents' ear, he would be the first to intuit any faint murmers of a coming zeitgeist, ready before others to mount and ride the crest of its wave. Elusive and paradoxical, he was of undefined species. His every stance, utterance or movement, was considered, economical and eloquent: even with no costume or make up he was self choreographing, 'hiding in plain sight'. On or off stage he was adept at leading everyone a merry dance, rock journalists especially. But this book is not primarily about David Bowie, it's about the other man, the same man; in the words of his wife Iman, 'I married David Jones, a totally different person.'

Everyone relates to their own version of David Bowie, but should anyone become aware of my having met him, they see it as a chance to glean any scrap of new information, however banal, that I should wish to impart.

I was once having a conversation with an attractive young stranger; a one way conversation it was, for it so happened that all she wanted to talk about was David Bowie. Afterwards, a friend who had been listening in, asked why on earth I had never mentioned my connection to the legend. I mumbled something about not being a show-off. He scornfully upbraided me, 'Oh, what a modest blossom: always thinking of yourself. Don't you realise, you could have made her day.'

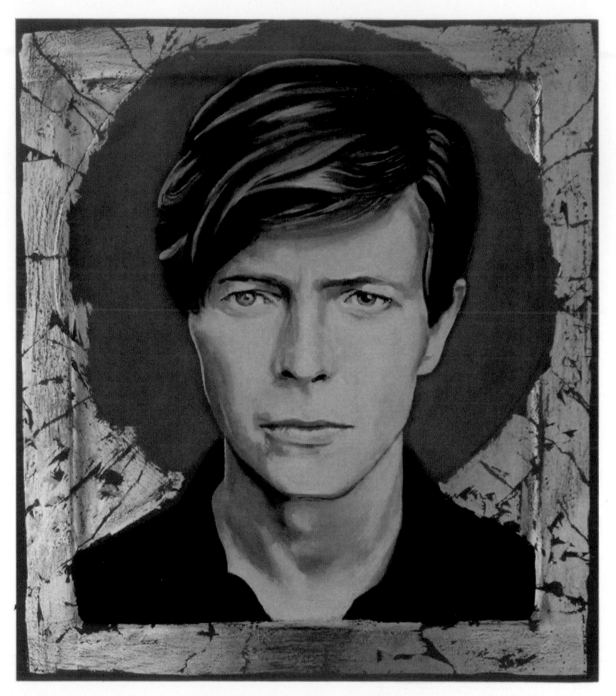

An icon in the making

I greeted the shock of David's death at first with a faint, sad shrug; the full impact was slow to dawn. If a drowning man is said to see his whole life experience on an instant in total recall, I was to experience a small death that lingered, and as it did so, forgotten incidents gradually returned with an extraordinary clarity. I felt compelled to write them all down, with the desire to share them.

This book is written from the perspective of someone whose path, once upon a time and intermittently, crossed that of a man called David Jones, who also happened to be David Bowie. The times spent with him span the 1980s into the early 90s, in London, Venice and Los Angeles. One knew then that what was passing was somehow special and a privilege but was also distinctly aware that to dwell on this knowledge could only distort the experience, even to the extent of losing all perspective. Only now, after his death do I look back, and with a considerably maturer eye evaluate and appreciate what was then unravelling. Hindsight is a wonderful thing: it can be enlightening, it can also be embarrassing. I attempt to look back with a measure of honesty, balance and clarity; certainly with immense gratitude.

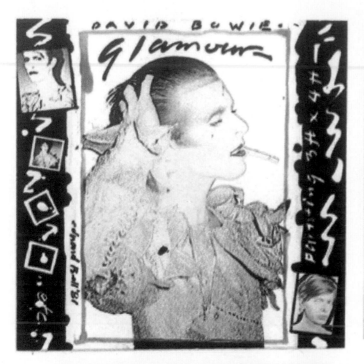

DAVID BOWIE
Glamour

edward Bell '81

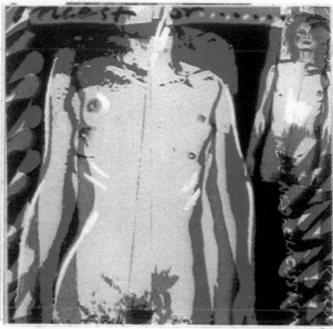

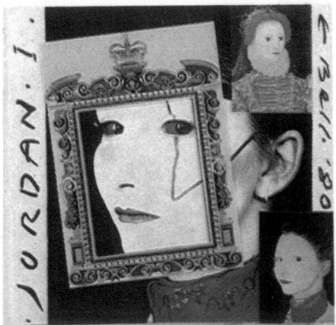

JORDAN. I.

E. Bell. '80

De Milo
Marilyn
Moderne.

Eighties Style

In the late 1970s, Bowie had withdrawn from the edge of cocaine excess in Los Angeles to settle in Berlin. He arrived with chum Iggy Pop under his wing, so one can speculate that a new sobriety was only relative; however the three albums described as the Berlin Trilogy ('Low', 'Heroes', 'Lodger'), were completed, and after almost a decade away, Bowie returned to London with 'Scary Monsters'. This could be seen as a fresh start, or as a return to where he left off in the early 70s, with his alter-egos and more pop-oriented music. Either way he was determined to win back his larger audience and substantially boost the bank balance. When I met him I didn't know all of this; nor would it have interested me.

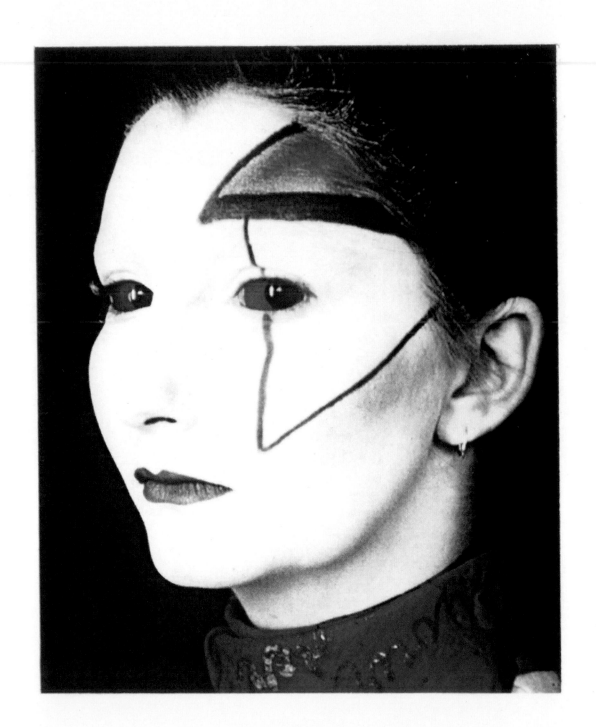

An Introduction

London 1980: At the Neal Street Gallery, my first exhibition, *Larger than Life* is a collection of large portraits, of friends and acquaintances, models or minor personalities on the London scene; they are more about the mask than the personality; with plenty of colourful make-up. They are all based on photographs I have taken, some featuring the 'red eye' caused by taking flash photographs with a cheap camera to emphasise the fact.

At the private view I stand alone amidst the crowd, anxiously looking at people looking at paintings and trying to gauge their reaction. The gallery owner sidles up to say that someone across the room is keen to meet me; he nods across the well-filled space. I glance that short way to see a slight figure, in scarlet trousers and citrus yellow, short-sleeved shirt; most offensive, though, is the fact that this slender character is peering at the Jordan painting [1], whilst wearing dark glasses; if not blind, he is certainly visually challenging, most probably an American tourist.

He shakes my hand. 'Hello, I'm David.'

Quite an interesting conversation develops, and as it does, so gradually it dawns on me that this isn't just David... this is David Bowie; and David Bowie is asking me if I can paint the cover of his next album...

'Oh, and by the way, the deadline's a week today.'

There can only be one answer.

[1] Jordan was an artwork in the flesh. She had worked with Malcom MacLaren and starred in *Jubilee* the Derek Jarman film; image-wise she was a reincarnation of Elizabeth I enhanced by wearing blood red contact lenses over the whites of her eyes.

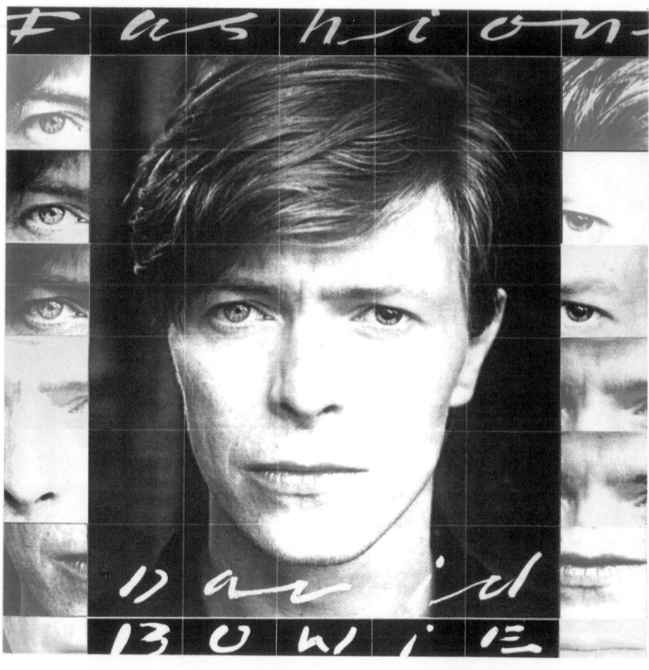

Brothers

The following evening we met for a meal in a Covent Garden bistro and got to know each other a bit. David displayed humour and seriousness, charm and an incisive wit. We discovered a shared upbringing in the dreary South London suburbs of the 1950s – silent Sundays, corner shops, black and white television, trolley buses and cod liver oil. At that time we also revelled in the 'Davy Crockett Craze,' had both proudly worn our 'Coon skin hats.' [2]

We didn't talk much about the recent past. He, only to mention that his time in Los Angeles was 'scary: I was several times close to overdosing... attracting some heavy people and situations... I slept with a gun under my pillow...'.

He mentioned an elder brother who was schizophrenic, and I had an elder brother who was severely retarded (in hindsight, the shadows of these genetic quirks perhaps coloured our own personalities, and were on occasions to colour our own subsequent relationship). He was proud of his son Zowie, who was one day 'going to be a professional skier'. He seemed less inclined to talk about his mother or his wife, Angie.

There was a difference between us that evidently amused him: whilst I had been sent away to boarding school, he had been travelling to central London, to explore the *Marquee*, coffee bars and girls. Thereafter his leg pull was to see me as posh and to mimic my accent.

[2] David Crockett (1796–1836) was killed at the Battle of Alamo. James Bowie (after whom the fighting knife is named), an exact contemporary, also died there.

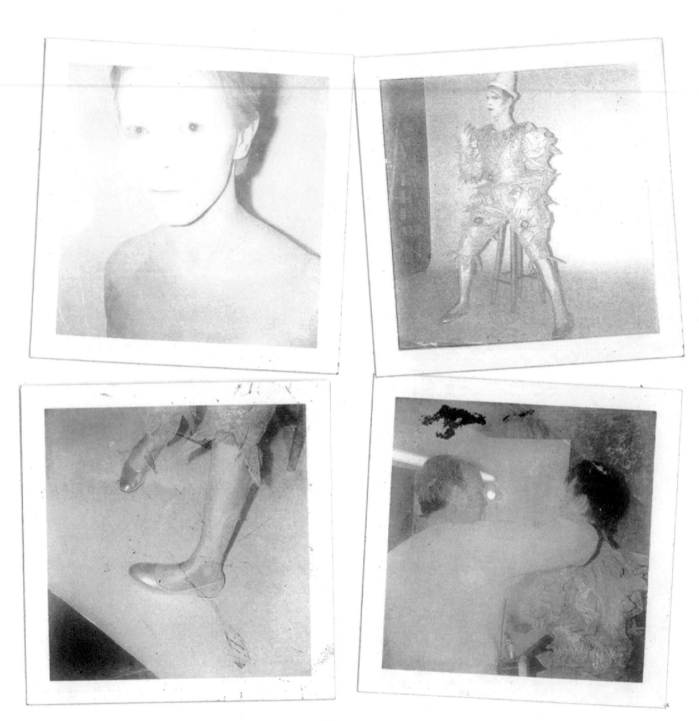

Memories fast fading...
Photo session with Duffy

Shoot

All I knew when I turned up at the photographic studio near the British Museum was that David and I had established a rapport, and that he wanted me to come up with an idea and paint him for the cover of his forthcoming album. I had my Pentax camera, a few rolls of film and an open mind.

I did not know that Duffy, (whose studio it was), was determined to do the cover himself, as well as the publicity photographs.

I knew nothing of a clown costume or its particular provenance and significance in Bowie lore.

I hadn't yet heard the album music or discussed any visual concept; and all this was fine by me; nothing to clutter objectivity or what clarity of vision I could bring to the job.

When Duffy had eventually finished taking his photographs of what to me appeared a pointlessly absurd Christmas tree clown (why was he portraying the clown, the innocent fool, when he was neither innocent and certainly no fool?), I approached Bowie somewhat nonplussed; simply committed to following my instinct and to dismantle the apparition before me. Quite tentatively I asked him first of all to remove the hat, then step by step to mess with his hair, smear the make-up, shrug the costume off one shoulder. I had feared that he might refuse at any stage; instead he caught the drift and ran with it- quicker on the uptake and giving more than any model I had previously worked with- he seemed to anticipate the moves as they entered my mind. The creative flow swept the clown doll away, tossed and stripped it, leaving a proud hero, unbowed and romantically dishevelled standing defiantly in its place.

This was an image no longer wistful, pretty, safe or fey, but a glimpse of glamour in its dangerous extremity; decadent and blatantly seductive. Afterwards, happy with the way things had gone, Bowie made one stipulation: that in the finished painting, his naturally fair hair should appear tinted, 'because in America I'm known as the red haired bisexual.'

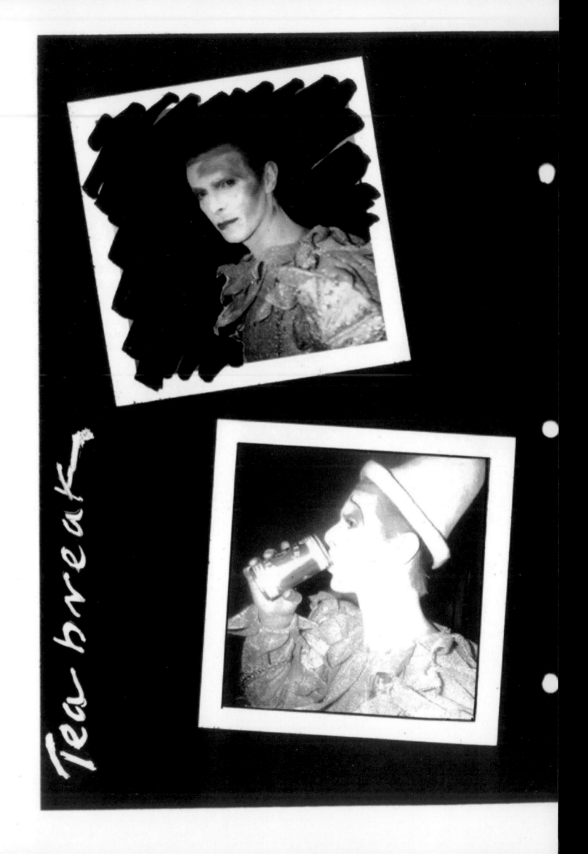

Tea break

Polaroid diary pages

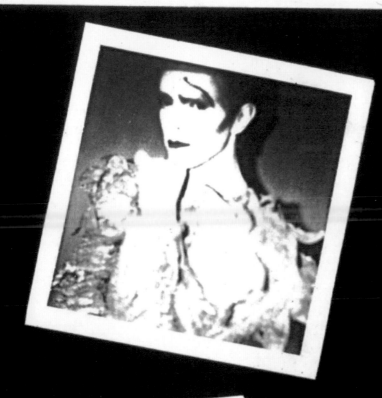

7·6·80·

creeps

SIDE ONE.

It's no game (No. 1).
Up the hill backwards.
Scary monsters
(and super-creeps).
Ashes to ashes.
Fashion.

SIDE TWO.

Teenage wildlife.
Scream like a baby.
Kingdom come.
Because you're young.
It's no game (No. 2).

Edward Bell '80

superns

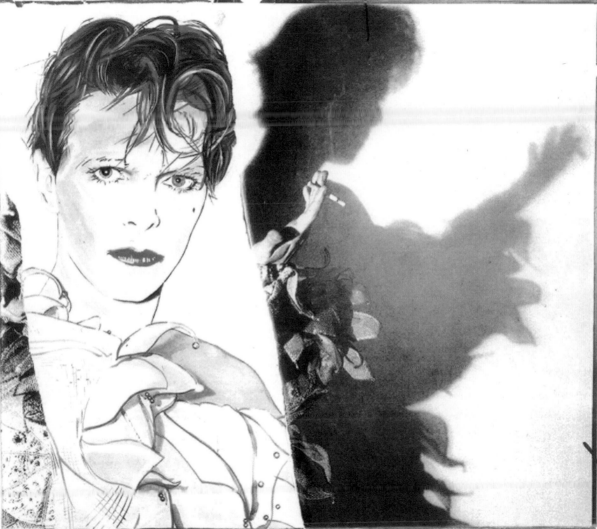

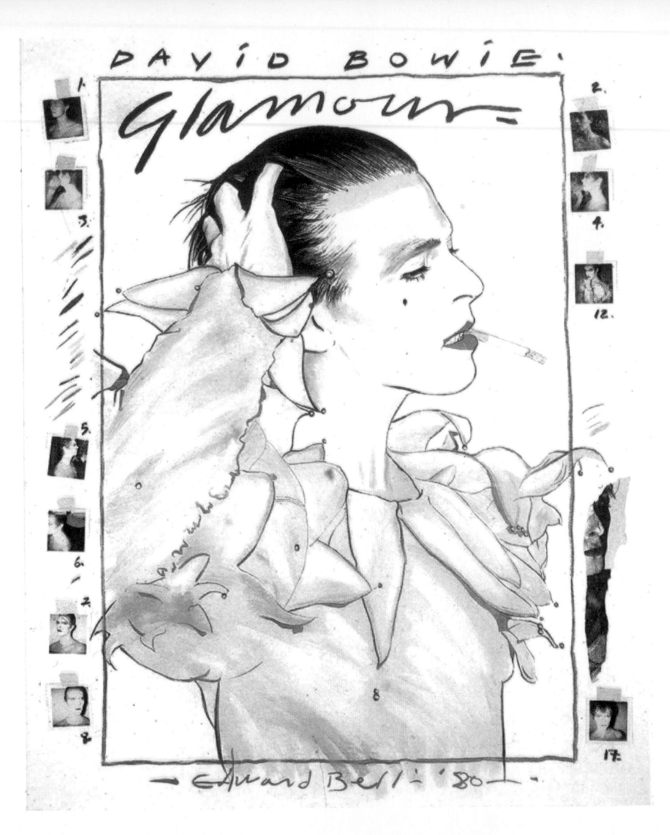

The next day Duffy paid me a call. He handed me a photograph, which he had taken of my version of the radically restyled clown. He patted me on the head. 'There you are, son, now just do what I say, and colour that in for the cover.' When he left I tore the picture in half: I already had my own to work with (later on though I picked up a fragment and found it useful to stick in the background).

A week later, when Bowie came to see the finished 4 x 8 ft artwork he took one look and said instantly, 'Great, that's it.'

But when I asked him to spot what was wrong with his portrait, he couldn't see it. I explained that to suit the composition I had reversed the transparency, and thus in effect, he was examining what he was most familiar with: his face in the mirror.[3]

Duffy was also present for the unveiling not saying much, but genuflecting and smiling weakly as Bowie extolled the merits of the 'larger than life' artwork.

[3] This later caused letters from indignant fans, pointing out my mistake.

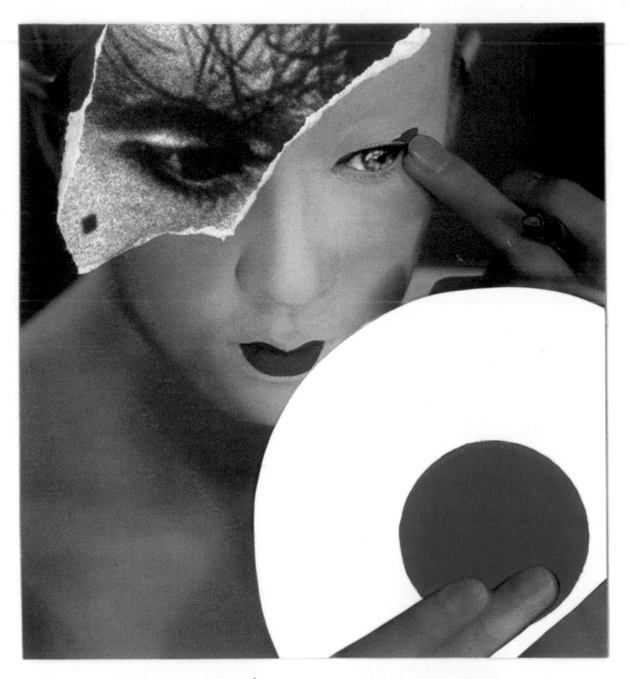

Land of the rising sun, Zen masters and kabuki

Basement Flat

In the days that followed, and apparently at a loose end, David would drop by at my very basic basement flat on the Earl's Court Road.

We played records by: The Psychedelic Furs, Amanda Lear, Mink de Ville, Tom Waits, Eno, Iggy and the Stooges; he carried a pocket tape machine with mini tapes, and tried to ignite in me an enthusiasm for traditional Japanese folk songs.

We talked about fashion in general and what we were currently wearing.

We discussed paintings and painters, in particular, the German Expressionists and the books we were reading by Yukio Mishima and Gunter Grass.

He once asked if I ever dabbled with make up. I thought of nightmare journeys, on the last train on the Northern Line, hiding behind a copy (large format in those days) of *The Times* newspaper. But before I could answer he grinned and commented, 'Great for pulling the birds, wasn't it.'

In retrospect, what we didn't much talk about were Sex, Politics or Religion (although David did express the vague thought that one day he might retreat forever to a Zen Buddhist monastery).

Eventually one or the other might suggest sauntering off for a pint; he would put on his dark glasses and we would wend our way down the Earl's Court Road to some grubby nondescript pub, and no one would give him a second look.

Instinctively you knew and were eager to buy your round, to keep up the precarious reality of a meeting as equals. It was a tightrope for both, and each of us lost balance on occasion: if he retreated to the refuge of his pedestal I could only fall; but his reach was long and always – eventually – extended.

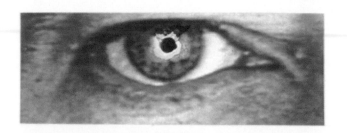
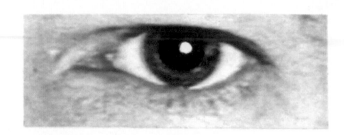
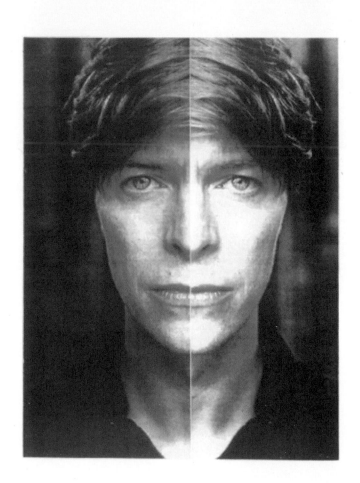
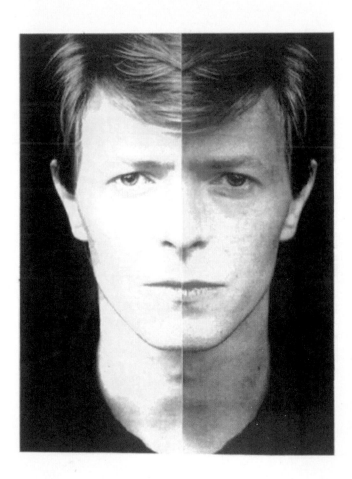

Balanced?

Mixed Messages

There was a particular dilemma to overcome in working with Bowie. One had to become used to the unsettling sensation of having to constantly decide which side of his face to relate to.

His right side (reason): the blue eye with the pupil capable of adapting normally to differing light conditions– icy blue; blue-eyed boy; the Aryan; the Tin Machine.

His left side (intuition): the green eye with damaged pupil permanently dilated, adapted to seeing in the dark (also characteristic of a normal pupil when gazing upon beauty); the gypsy; the scary green-eyed monster; the alien.

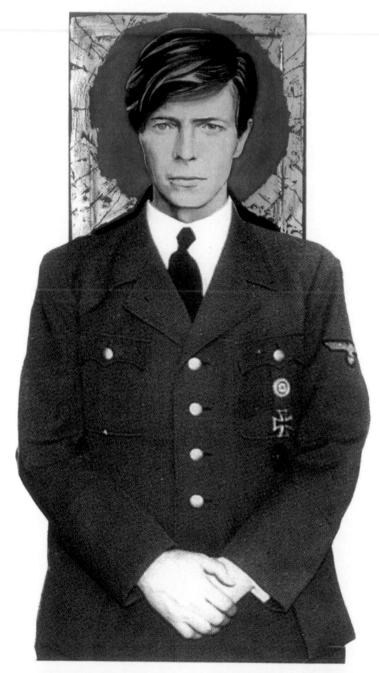

A 'good boy' haircut, or lingering reference
to the 'Führer Lick'?

Quest

David didn't then drive; he always had a hired car waiting to take him wherever his whim might lead. He was already collecting up and editing his past and, wishing to retrieve some negatives, we were one day driven to the studio of photographer Brian Ward, in Heddon St W1 (a then quiet, nondescript mews), behind Regent Street which had been the setting for the 'Ziggy Stardust' album sleeve. A solitary young girl clutching an Instamatic camera was there, gazing up at the famous 'K.West' sign. David winked at me, walked up to her, and said, 'Give us your camera, love.' I photographed them together. She was pole-axed, paralysed, struck dumb, speechless; she might even still be there, rooted to the pavement.

Crumpled

There was a visit to Derek Jarman's flat to discuss the possibility of collaboration on a film. While this was going on, David's eye alighted on a crumpled Malboro Red cigarette packet, prominently displayed in the centre of an otherwise empty mantelpiece – apparently the one Bowie had discarded on his last visit. An awkward silence descended. David reached out, pocketed the offending reliquary, and turned to an embarrassed Jarman. 'Don't be silly, Derek'.

Steve Strange

At the video —

CoCo

Blitz

A visit to the Blitz club was not something I relished, in light of only recently, having been denied entry by the host, Steve Strange. Flanked by bouncers, this fastidious arbiter of a particular genre of fashionable dress would, on club night, stand at the door and, scanning the crush, identify with a languid finger the 'Chosen ones' for that night.

Things were different when David persuaded me to tag along. We sailed in; the place was packed, and all the high priests and priestesses were in attendance (Boy George, Marilyn, Gary Numan et al.). As we entered, the crowd gave off an air of being on the verge of a collective nervous breakdown, but parted like the Red Sea to allow passage for their God. David occupied himself by having fun in picking out those he deemed suitable to appear in his *Ashes to Ashes* video. As he circulated, so the closely packed, crowd followed, thus if I stood as far as possible away from him I was able to breathe, even find space at the bar to have a quiet drink and a fag.

The only discordant note that evening came while we sat in the gallery surveying the massed congregation below. One of the elect approached David offering to procure any, or every, drug under the sun, should he so wish. David didn't even bother look at him. 'Fuck off,' he said without emphasis.

Performance

David wanted me on set during the shooting of the *Ashes to Ashes* video, in case I had anything to input. I didn't– the whole thing was storyboarded in detail, carefully scripted and choreographed and, besides, it was back to the bloody full clown rig: hat, make up, costume and silver slippers.

It turned out to be a long, boring chilly day at the seaside, alleviated only by the company of Steve Strange, (who had decided that I was his new best friend) and also Richard Sharah, the make up artist, who entertained us with a performance from his protruding tongue, which was sinuous, prehensile and of quite staggering length.

Under the skin : Elephant Man

With 'Scary Monsters' wrapped up, Bowie had gone to New York where his stage performance as the Elephant Man received unanimous acclaim.

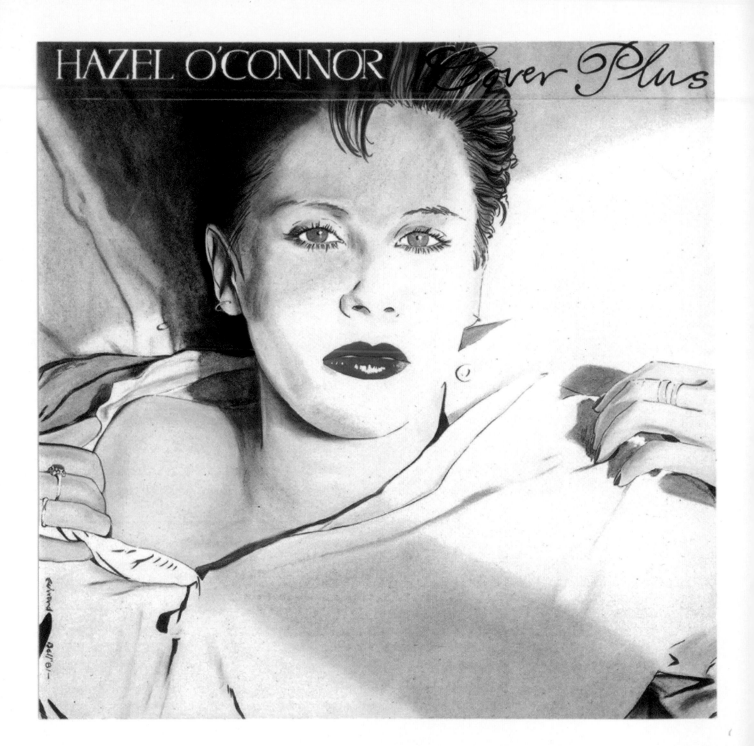

HAZEL O'CONNOR
Cover Plus

Cover Plus

A year on, Bowie long gone back to New York or Switzerland or wherever. 'Scary Monsters' had been released to great acclaim and I, by association, had not just plentiful offers of work: but I was also invited to premieres, parties and the weddings of people I barely knew.

Amongst them, Hazel O'Connor contacted me for an album cover, and of course, as she was an ardent Bowie fan, this was no random choice. She already had the 'look', hair cut and colour, so I suggested that I photograph her in bed: Hazel O'Connor as Bowie, therefore, in a sense, in bed with Bowie. She had apparently only met the man once when he appeared in her dressing room to offer his songs for her film *Breaking Glass*. She turned him down; so instead he asked her to cut his hair. She vividly remembered that the only thing at hand to drape across his shoulders was a drying up cloth, which to her great embarrassment, was filthy and stunk to high heaven.

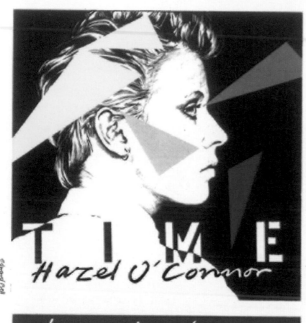

Record covers : early eighties

In Pursuit of the Ovoid

One day, out of the blue, a phone call:

'It's David.' Pause.

'I don't think I know any Davids'. Penny drops. 'Oh, that David.'

He was once more in London and named a rendezvous: at Sotheby's Fine Art Auctioneers, New Bond Street. When I arrived David was already there, wrapped in an ankle-length black leather Gestapo coat: back turned, scrutinizing the window display. I crept up behind and spoke in a low voice, 'And who do you think you are?'

He jumped and spun round, making it clear that my attempt at humour was not appreciated. He asked what was happening in my life and I told him that I seemed to be living clichés... slipping on banana skins and dating a Swedish model. 'Eat a lot of bananas then, this Swede?' he retorted. He went on to explain that as he had never before been to an auction, he wanted me to do the bidding for him. I was appalled; what made him think that *I* had? It didn't matter, as once seated he quickly got the hang of it. From then on there was, literally, no stopping him.

I couldn't for the life of me understand what was driving him to accumulate such an eclectic mix of so many mostly mediocre pictures, mainly by obscure painters. When I asked him later, he explained that he had gone only for works that had featured suggestion of an egg shape and then changed the subject, leaving me no wiser. What I did observe was that, once he'd made up his mind wanting something, he just kept on bidding regardless until he came out on top. He had no ceiling, and anyone coming up against him didn't stand a chance.

CLASSIX NOUVEAUX
secret
CLASSIX NOUVEAUX
©Edward Bell

RIKKI SYLVAN
THE SILENT HOURS
©Edward Bell

ANGLETRAX
AHACS41 · ANOREXIA NERVOSA
THINGS TO MAKE AND DO
©Edward Bell

ESPIONAGE
©Edward Bell

PYRAMIDS
Celts and Cobras
Shefia PYRAMIDS

Is another Explorer

The Lone Voyage of the Great Explorer.

HAZEL O'CONNOR.

sons and lovers

Kajagoogoo
Big Apple

WELCOME TO THE DJEMILA SOCIETY

17

Edward

A FILM BY MARCUS THOMPSON
FEATURING THE WORK OF EDWARD BELL

Introducing Jayn Rosamond Original music by Stephen Lipson

DOLBY STEREO
IN SELECTED THEATRES

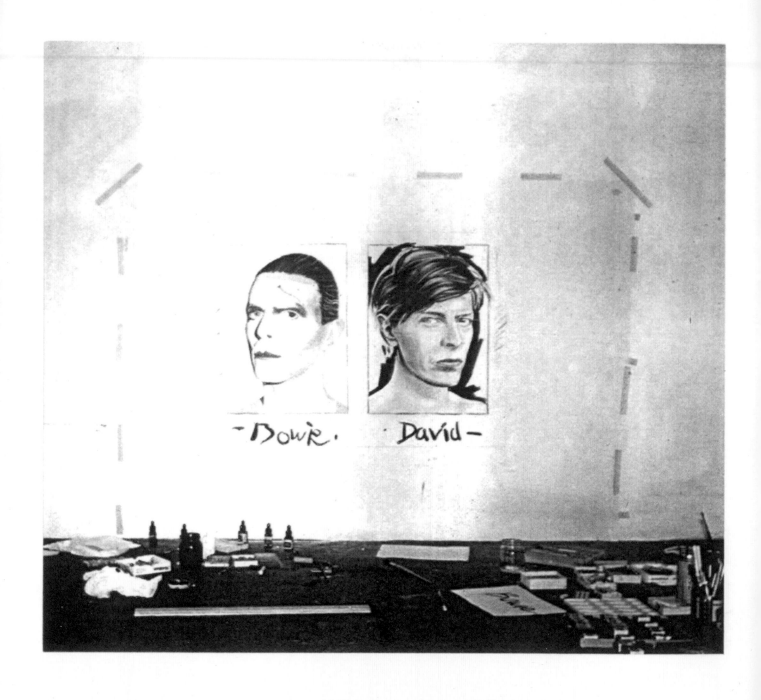

1981 : Work in progress : basement flat

This and That

I was round at his current London roost at one time (he preferred rented service apartments, rather than hotels) when he produced a set of Kirlian photographs taken of the energy field radiating from his hands. He started a cosmic eulogy about them, but on noticing my blank expression put them aside (perhaps thinking it all too "Ziggy").

Sometimes we went to the Chelsea Arts Club; on one occasion meeting Derek Boshier (painter responsible for the 'Lodger' cover artwork) who also, David revealed, had been giving him some art lessons. This was a surprise, as up until then he hadn't mentioned that he himself 'dabbled with a brush'. We also met George Underwood, talented illustrator and a friend, apparently dating back to cub scouts. It was easy to understand their rapport when listening to an effortless display of such wit and repartee. Bowie could lead a gang (like Tin Machine) but ultimately seemed to prefer one-to-one relationships (as indeed did I).

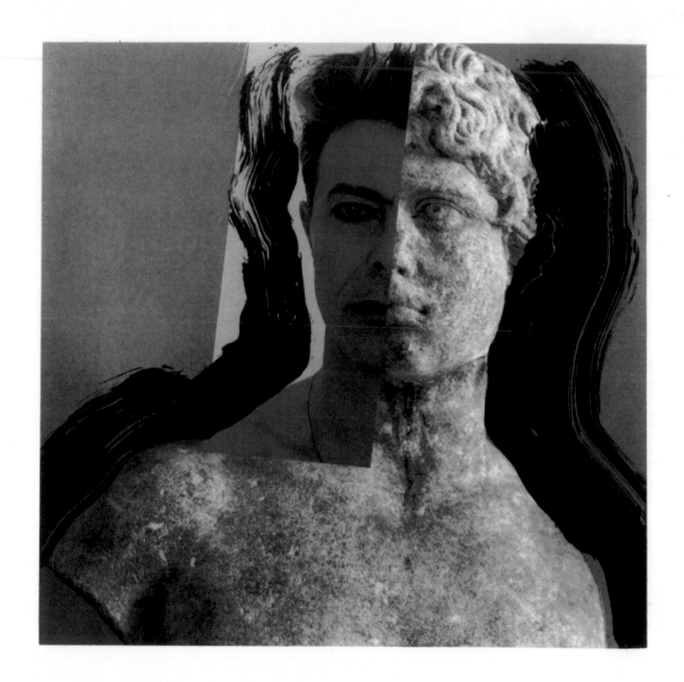

1983 saw the release of Bowie's most commercially successful album, 'Lets Dance'. 'Tonight' (1984) and 'Never Let Me Down' (1987) were less successful on all levels.

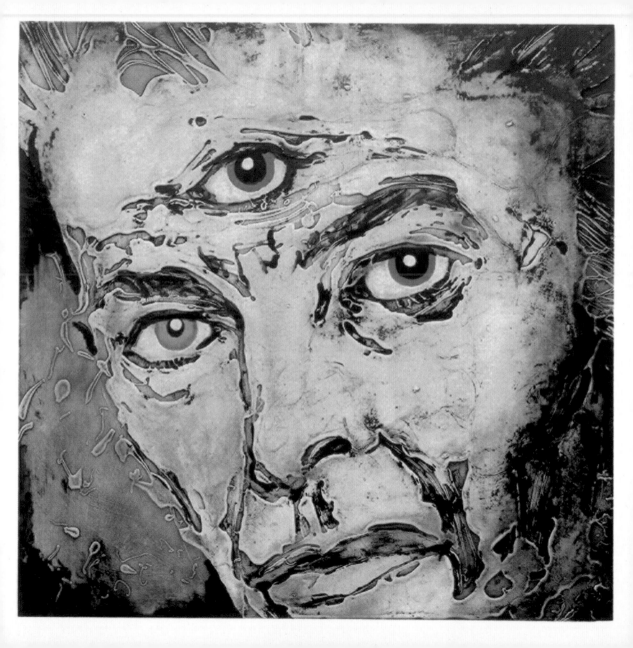

Kamikaze

Bowie was off again. Life went on; slowly and in the wrong direction.

One day a group of smartly dressed young Japanese arrived on the doorstep of my basement flat/studio. For a time they sat silently looking at the surrounding paintings; a whispered conversation in their native tongue, then one of them – the spokesman, it seemed – pointed at a picture. 'Ho-Kay. We have that one, that one, that one, that one, that one and that one.'

I named a price; they didn't blink, opened their wallets, bowed politely and left. I thought, thank goodness they've gone, reached under my chair for the tin foil and carried on 'Chasing the Dragon'.

Someone nicked the Christmas card that Bowie sent me that year... and that, I thought, was the end of the story. I got on with my life, which had become a downward spiral, deepening my acquaintance with heroin. I carried on sparking for a while, until I fizzled out, almost completely.

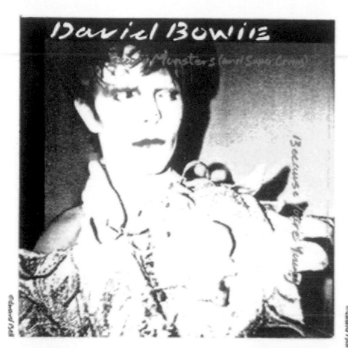

David Bowie
Scary Monsters (and Super Creeps)
(Because you're Young)

©David Noll

MISSING PRESUMED DEAD
Say it with Flowers

©David Noll

Hazel O'Connor
TIME

©David Noll

CLASSIX NOUVEAUX

CLASSIX NOUVEAUX
For Ever And A Day...

©David Noll

Curtains

I was made aware that the Stones were on the look-out for someone to design their forthcoming sleeve and an audience was duly arranged with their drummer, Charlie Watts (the only member of the band in England at the time).

I met him in a suite at the Ritz. Midday, but it was dark inside, all the curtains pulled; he was watching a moon shuttle live on TV.

He appeared be-suited and polite, laconic but direct. My hurriedly prepared roughs didn't impress him, and when he heard that I had worked for Bowie, he simply shrugged his shoulders and summed up the position: 'Well, you've no chance then. Mick wouldn't play second fiddle to Bowie.'

I carried on illustrating for magazines and less well-known bands; spent a year in Paris; even went feral in India for some months, but eventually had to face it: I was overdrawn, health, wealth and creativity spent. I had to face myself.

A commission aimed at launching a new brand of German cigarettes failed to elicit images of any merit, which led instead to mutual chagrin, solicitors' letters and much huffing and puffing.

I was driven in a tinted-windowed, shining slug of a stretch limousine to the estate of Elton John. Remote-controlled gates slowly swung open, his mum and dad waved from the lodge, and a cohort of minders (in green tracksuit uniform) jogged in escort, opened doors and ushered me into a vast ante-room to await His Highness – a long wait that allowed examination of walls crammed with paintings, where original Magrittes hung amongst sentimental twaddle. Eventually, flanked by a handsome henchman, Elton made his entrance. He proved awkward, difficult to pose and extremely shy; he bantered with his bat man, was generally nervous throughout, and was unable to look me in the eye. That such an overall bemusing encounter should have led to such a pallid portrait was much to be lamented.

BARELY HUMAN

Drawings + Paintings

Florence + Venice

Edward Bell '88

55 Princes Gate, Exhibition Road
London SW7

7.8.9. JUNE 10 A.M. - 10 P.M.
PRIVATE VIEW. TUESDAY 7 JUNE 6.30 - 10P.M.

Bowie seemed once more to have lost his way, and the solution this time was to further lose himself within the identity of a band. 'Tin Machine' released their first album of high decibel, gritty rock in 1989. The next and last, 'Tin Machine II' was put out in 1991.

La Serenissima

Fast forward to 1989. After a long marriage, my divorce from China Girl was finally accomplished; my flat had been sold and debts cleared. Once again fit and in the rudest of health, it was the brain that needed stimulating.

I disappeared to Italy for a year – cheap pensione, prosciutto, bread, cheese, wine, sunshine and painting and Michelangelo.

In Venice I bumped into a friend from London who said that his sister had a flat available for very little rent, but only to the right person. I would have to be interviewed. I duly met her in a bar, the beautiful Lady Rose. I offered her a cigarette, 'Oh, *Natzionale*,' she drawled, 'I smoke them too; all the best people do; it was Mussolini's favourite brand... actually.'

So I moved into the canal level apartment of the palazzo where she and her husband occupied the piano nobile.

Out of her subsequent generosity, I was often invited upstairs for a meal. One day she appeared in a complete dither. 'You've just got to come to dinner tonight, I've invited someone very special.'

I probably pricked her bubble when I answered. 'Oh, him; yes, I've met him before.'

So David turned up, formally attired and on his best behaviour until he spotted me, likewise in a suit and tie, and burst out laughing. Without saying anything, we somehow intuited that in our own ways, we had had similar struggles in the intervening years, and had come to the same conclusions. We were 'in tune' once more.

He introduced his fiancée, Melissa Hurley, who had been a dancer on his 'Glass Spider' tour. Gracious and demure, she was persuaded to show off her new diamond ring, but it was all quite stilted– everything perhaps a bit too much for her? Be that as it may, the evening went well and Lady Rose undertook to organise their social life for the duration of their time in Venice.

Some days later, Lady Rose was outraged by the fact that her considerable charms were being neglected in favour of her dry, pedantic husband's more cerebral attractions. He was able, at the drop of a hat, and at extreme length and detail, to lecture on Venetian history and architecture; all of which, with rapt attention, David set about soaking up.

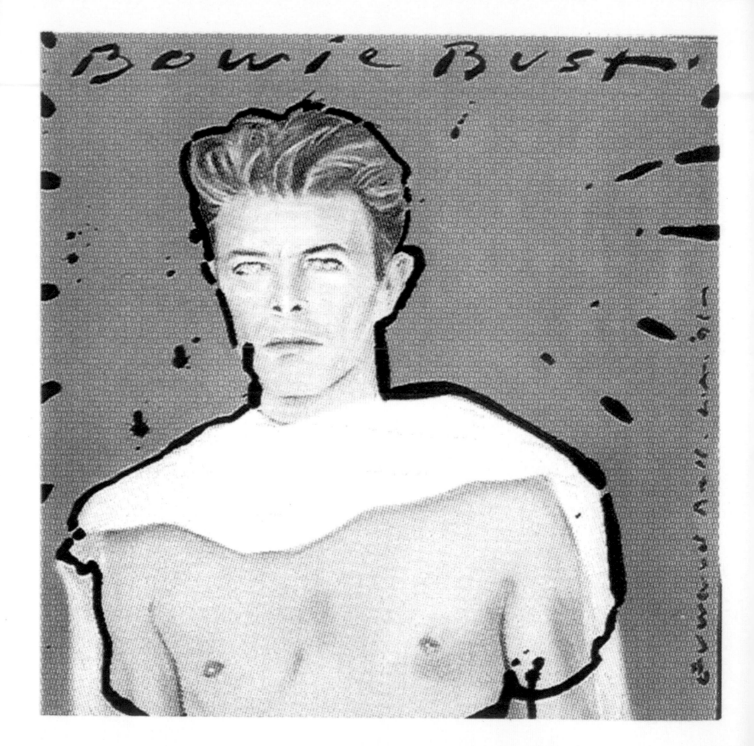

Working Class Hero

A subsequent evening found us all in another somewhat elevated milieu. At one stage David steered me to a sofa, extracted a Walkman and two pairs of tangled earphones from his pocket. He nudged me. 'Listen to this.'

It was a tape of his forthcoming 'Tin Machine' release. So we two seated people, on an island of our own, were blasted away by sound, whilst other guests, mingled, slow motion miming, mouths opening and closing in an aquarium of silence. It wasn't really the music that was principally making me feel uncomfortable. After one side, I suggested that we share this experience with the others. David, with genuine modesty, seemed surprised. 'Do you really think so? Which track do you suggest?'

Naturally I replied that they were all equally brilliant, so any would do. After some thought, he took the plunge, found a tape deck, and played, at truly chandelier-shattering volume, his version of John Lennon's *Working Class Hero*. The assembled lords and ladies, Marchese and Marchesas, along with several generations of the Guinness family, politely tapped a toe or nodded a head. At the end, rather shell-shocked, and in a decidedly tentative fashion, they began to clap.

David seemed to be in a quirky mood. Later, he sidled up and spoke discreetly. 'Look Edward, I've got things to do tomorrow, couldn't you entertain Melissa? Take her out shopping or something?'

I was aghast; Melissa and I had hardly exchanged a word, and besides, I knew very little about the kind of shopping implied– Murano glass, jewellery and designer dresses?

Their pre-nuptial honeymoon at an end, David took his leave, promising to be in touch (this year, next year, sometime, never?).

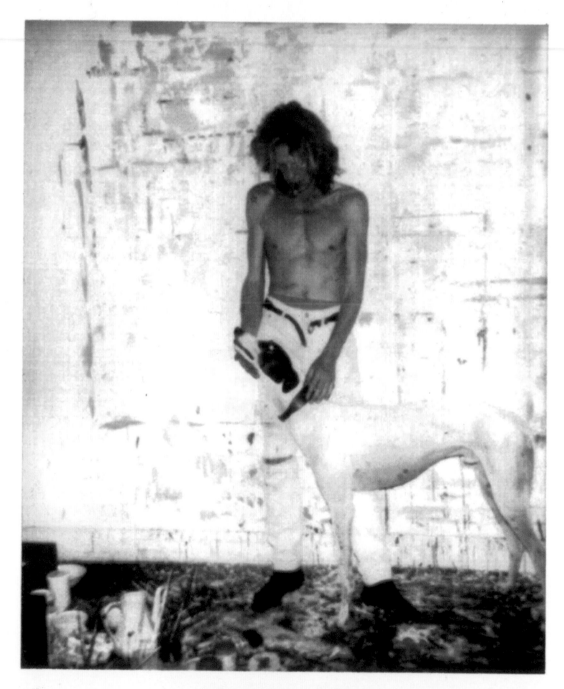

White Levis and Byron

David Who?

After a silence of eight years, coming across David in Venice and reconnecting had been a happy coincidence, that was all. There was no reason to expect or believe that our paths would ever cross again.

Meanwhile, two years on in 1991, and back in London I continued painting. I no longer sought even the bottle for comfort or distraction. I was, as they say, 'clean' – squeaky clean but penniless – renting a place in a mews off All Saints Road, with no bath, bare plaster walls, no carpets, not much furniture. Free of the past, happy even; I had a companion – a white greyhound I called Byron, who didn't talk much and was a good listener. No one knocked on the door; no one phoned at 2 o'clock in the morning.

So then… What the fuck?… Telephone ringing at 2 o'clock in the morning…

'Hi, it's David.'

'David, who?'

'David Bowie.'

'Yeah, sure!' Furious, I was about to slam the phone down, but checked myself as, just in time, I recognised a familiar chuckle.

'Oh that David. Well, where are you?'

'I'm in Mustique, but flying out to Los Angeles soon to finish making the second 'Tin Machine' album. I want you to meet me there and come up with an idea for the cover…'.

Knowing that he rarely used the same artist twice, and never having been keen to visit America, I rather prevaricated; I was also wondering, frankly…

If I go, who could lend me some pocket money… and what would I wear?

He pushed me. 'You've got to come; you're my favourite artist…'.

Well, that was it. Flattery got him everywhere, or rather, it got me to Los Angeles.

Would I be able to perform, come up with the goods? No matter, I decided. By now no stranger to those terrible twins, success and failure, I should be able to handle it, whatever the outcome.

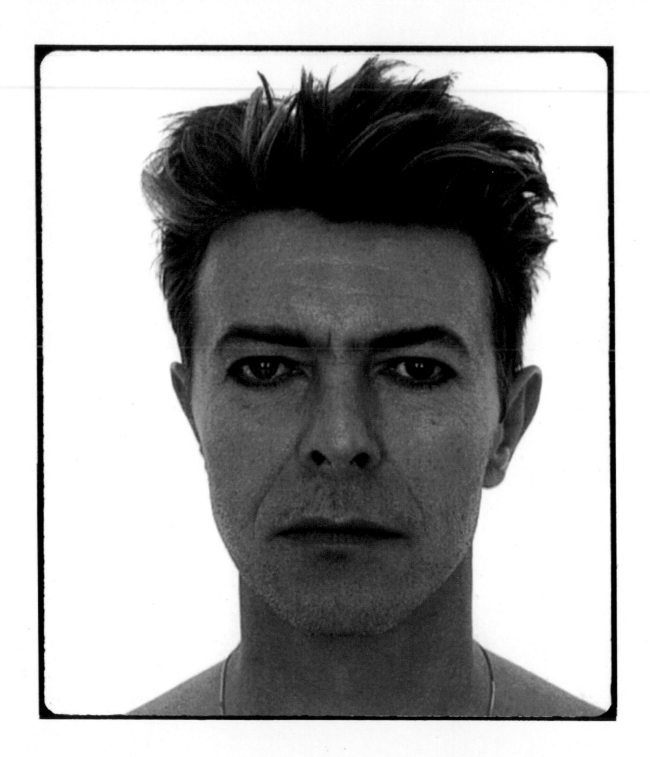

Davy Jones' Locker

Our primes had been arrested; pickled in powders and perfect solutions of chemical concoction.

Wild winds had rocked and rolled our vessels; deranged and scuppered, they had slowly sunk to the Stygian depths. In timeless suspension we had lain on ocean beds, eventually to rise again, leaving to flounder the maimed and the dead.

Venice had been an interlude: party time in celebration of recovery, but LA was going to be no rock'n'roll carnival; it was to be a gang of jaunty lads putting themselves together again– serious about what they were doing and leading a life dedicated to work.

Our forties had dawned, yet we were perhaps less aware of the ageing process than most; we had after all survived and, no longer living in the fast lane, we could slow time.

The mirror showed us an image barely changed. Yet in our maturity, we had learned many lessons; we were now stronger, fitter for life. Had we looked closer we would have seen that a large dose of arrogance had replaced any residual innocence.

At this pivot in our lifetimes, we weren't so much contemplating inevitable descent, as glancing onward and upward, the reborn turning a blind eye to any intimation of mortality.

Add to this attitudinal dyslexia a large dose of residual anger – the emotion that had to force itself to the surface in order to overcome addiction was now less focused and permeating all areas of life.

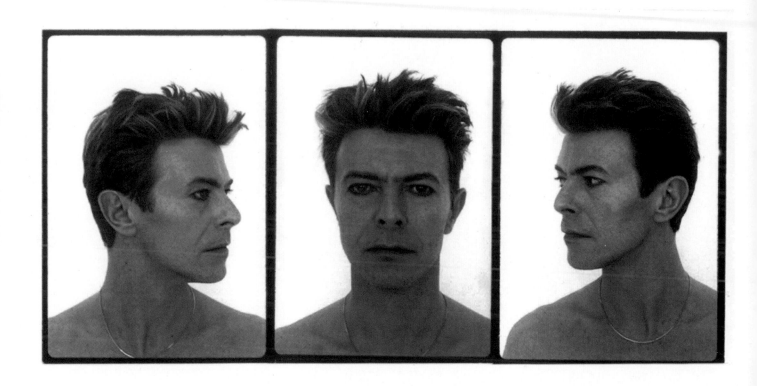

No City of Angels

Fast cars, gym driven, drug pumped. Starved of the moment, fast food, architectural famine. Aural interface of perpetual sirens. Colourless, bland, pointless, terrifying. A barren land nurturing large artificial smiles and enormous synthetic breasts. Were they all really, 'having a nice day'?

I flew to LA and experienced 'jet lag' for the first time. It seemed to last for the whole two weeks I was there.

The hotel was bland and the view from my room indescribable, because there was none. Everything inside was of the palest of greys, save a bowl of pristine, pumped up, garishly coloured apples. They were not, in fact, made of wax, but tasted like it. Everyone smiled and really did say, 'Have a nice day'.

That first evening David was busy and Coco was delegated to take me out for a meal. She was his personal assistant and when required, assumed the role of 'Miss Nasty' whilst David could ever remain 'Mr Nice'. However on this occasion she was 'Miss Nice.' Nevertheless, conversation was stilted and the food was awful. One couldn't say that I was disillusioned, for all my prejudices about America were being convincingly confirmed, but I was tired, and to my horror found myself rapidly slipping into the role of 'Mr Nasty'. When the desperately chummy waiter offered to clean my plate into a 'doggy bag', I chose my words carefully. 'Thank you, how kind, but I rather think that even my dog would turn his nose up at this...'.

Not a good start to a fraught fortnight.

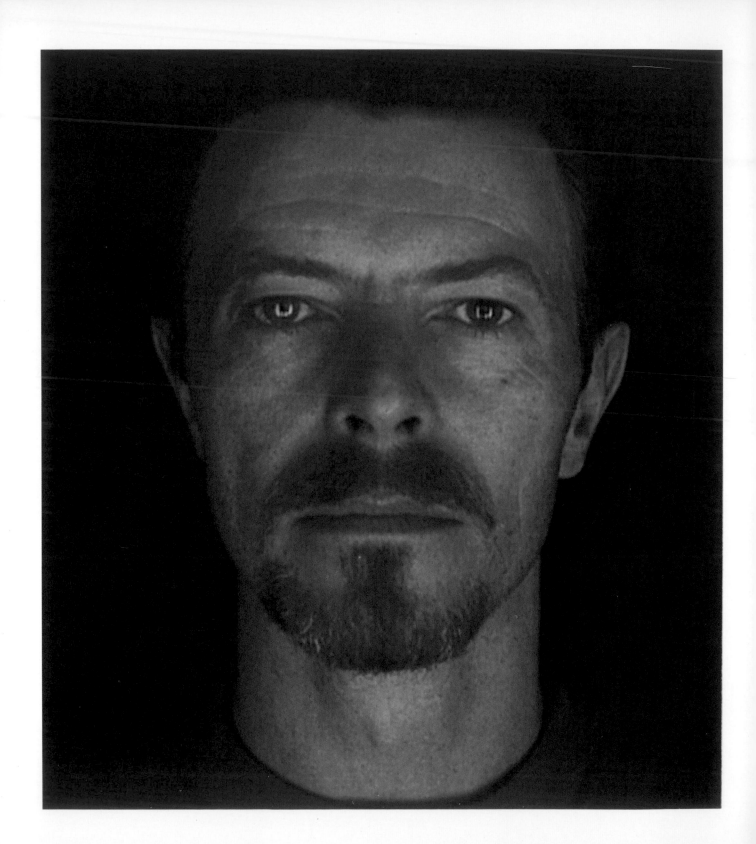

Cups of Tea

Next morning, after I'd been chauffeured (just round the corner) to the recording studio, David nearly toppled me with an effusive bear hug, which was some surprise, since neither he nor I were in essence 'touchy feely' people. I was surprised, too, to see him wearing a beard, which inexplicably put me in mind of a drug dealer, or diamond smuggler from Amsterdam (not that I had ever met many). I decided not to tell him.

After introducing me to the band (hip local boys, brothers Hunt and Tony Sales; and Reeves Gabrel, more brains than hip) and having played some of the new album, David asked if I had ever heard of Narcotics Anonymous? If so, what did I think of it?

Here was an easy chance to give flight to a current bee in my bonnet. I didn't, as I might today say something like, 'Brilliant for those it suits'. Instead I replied, 'Oh, it's simply a venue for 'moaning minnies' to get on stage and parade their woes: not my cup of tea.'

A pause. 'All right,' said David. 'Please yourself, but me and a couple of the boys are going later on to the Hollywood meeting, and you're welcome to come along.'

So I went.

At the meeting[4] new members were expected each in turn to introduce themselves. 'Hi, my name is... and I am a... (something) addict,' even if they'd been 'clean' for half a lifetime.

Negative thinking in my book, so when my turn came, I stood up.

'Hi, my name's Edward and I *used* to be a heroin addict.'

Tremor of hush: necks craned in my direction. Scowl from David. He brightened up towards the end though, because it was his turn to put the kettle on and pour the tea, which he seemed to thoroughly enjoy doing.

[4] A large proportion of those assembled were actors, musicians or comedians, at least suggesting that one would be well entertained.

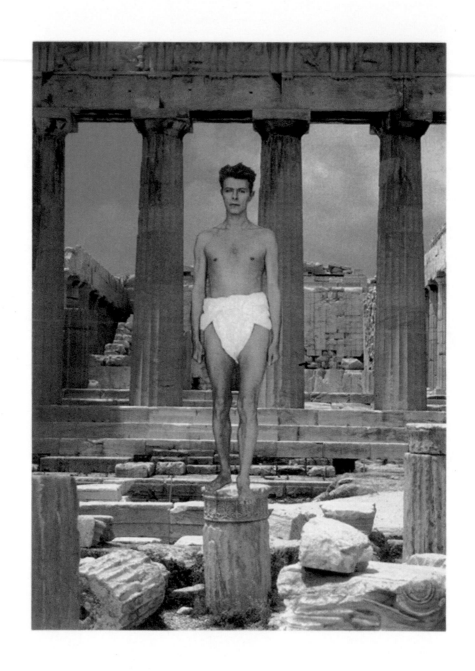

Pedestal

Black and white

I will admit, there were other occasions where I could have displayed more delicate tact. We were chatting at a record company bash; David was reminiscing about a drinks party he had given in Mustique: he'd had to have Princess Margaret thrown out because she was so drunk.

'Dlimey!' I expostulated, 'She sounds as bad as some of those pop stars one hears about.'

Black look. Straight to his pedestal and I longer existed.

We were, though, in agreement over Levi jeans, straight leg, button-fly 501s. They were something American that I *did* like, currently preferring the white ones, as opposed to the black that he had and the band routinely wore. The very next day David appeared immaculate in a white shirt, gleaming white loafers and white Levis. I couldn't help myself and exclaimed, 'Hey, it's the Milky Bar Kid.'

If looks could kill, well, I just died.

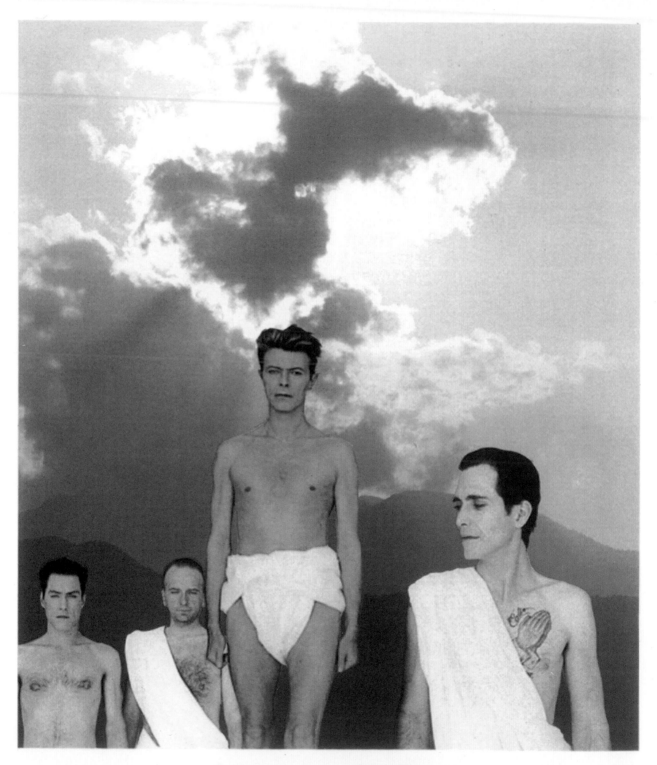

Some more equal than others

Cameo

One evening, a 'works outing' to the cinema was arranged. The band and I were taken by the boss to see a film, the title of which I have forgotten; more memorable were the recurring, violent scenes of gun carnage.

In a half-hearted post-mortem on the entertainment, Bowie kept silent until, suddenly, he leaped to his feet and mimed a series of epileptic contortions, like a limp puppet being jerked spasmodically into an inelegant dance of frantic death throes. We all went quiet for a moment, before bursting into spontaneous applause.

I'd never been to any of Bowie's shows, or seen him on stage, but now I could say that I had indeed seen him perform.

Big Fight

Another evening, another works outing. This time, David took us to his apartment to watch a heavyweight boxing match, a 'big fight', live on TV. Glasses of Coke or water were dispensed. He lay propped full-length on his emperor-sized bed while we crouched on the edge or sat on the floor cushions.

There was a big build up and ritual pumping of anticipation; the king and his courtiers were in for a treat. The bell rang, adrenaline levels soared and a ropey first round ended with an unconvincing knock-out.

This disappointing anti-climax brought our evening to a premature close in a similar way. A thoroughly disquieted David knocked our small party on the head and unceremoniously ushered his acolytes out of the flat and into the elevator.

I came away musing not so much on the unsatisfactory combat, as on the apartment and its furnishings – generous folds of heavily swagged velvet curtaining, ornate gilded mirrors, elaborate chandeliers and clusters of free-standing church candelabra. Evidently, although the Venetian interlude had left him romantically unfulfilled, he had not come away entirely empty handed.

Tinkering

When it came to discussing ideas for the 'Tin Machine' cover it turned out that David had none. I pressed him on what he was into 'art-wise' at the moment. He said that he was collecting old masters adding, deadpan, that perhaps I could paint one for the cover. There was, though, one huge restriction he imposed. 'Tin Machine' is a band; I just happen to be one of its members, so in no way whatsoever must I appear on the cover.'

Back at my hotel room, deep into the night, I racked my brains to come up with some appropriate solution to the problem in hand; something to justify my being hosted on the wrong side of the Atlantic:

'Major Tom... sitting in a tin can...'

Hawkwinds, 'Silver Machine'.

Tin Tin.

Rin Tin Tin

Tintinitus.

Tintinabulation.

Tin man without a heart.

In America the traditional family photograph is known as a tintype.

Tin foil.

Tin Pan Alley... blind alley, I was getting nowhere, time to change tack... tin tack... Oh, for heavens sake...

I decided to test the amenities. The hotel boasted a jacuzzi on its roof; I gave this a miss, unsure of the purpose of such a thing, let alone the etiquette involved.

But, Los Angeles, a 24-hour city: a chauffeur driven company car on call around the clock. We seemed to drive for miles, but eventually ended up at a vast warehouse: a supermarket for all manner of art materials. I made my purchases then asked to be driven to an art bookshop. Whilst idly browsing a book on classical Greek sculpture I came across the photograph of a stylized figure. Something shifted and I felt the cogs of creativity being gently oiled.

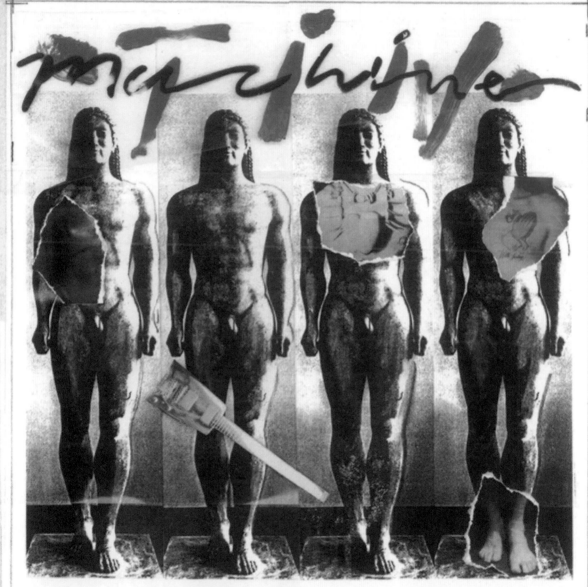

Jolly good, a splendid effort, Keep it up.

ORIGINAL
Album cover
sketch

Nude Man

Later, when ideas had coalesced and finished roughs were in a state to be viewed, I went to the studio to show them to David. Liking what he saw he wanted to know about the images in depth, and listened, evidently rapt, to what I had to say:

'These four figures, identical in their anonymity, represent the band. The statue is an example of the type known as 'Kouros', meaning a sculpted youth, from before 500 BC. They always stood symmetrically upright, but leading marginally with the left foot, signifying perhaps the dominance of an intuitive path...'. A band member wandered up and peered over our shoulders wanting to know about the curious 'nood' men. David, expressing distain for such ignorance, proceeded to explain. 'These four figures, identical in their...' Not only had he listened, understood and absorbed, he had made the knowledge his own, and repeated it word perfect. He went on to sign the roughs with a flourish, as though a headmaster marking an essay.

Subsequently I was photocopying these roughs on the hotel machine, overseen by a bell hop who took one look at the Kouroi and exclaimed, 'Jeez man, that's pornographic!'

I ignored him. 'Must be bloody barking,' I thought.

But that wasn't so, as I subsequently discovered; he was simply Mr Average American.

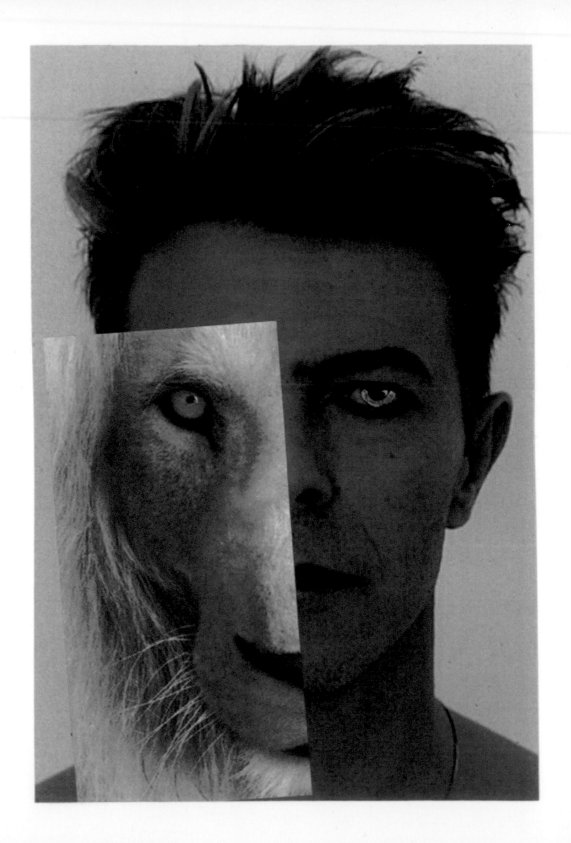

Iman

The circumstances in David's life, since I'd last seen him in Venice, had changed considerably.

He was learning to drive and planning to buy a silver-blue 'E' type Jaguar (Tin Machine?). He often disappeared in the evenings, not to rock 'n' roll, but to sit at a computer screen for hours on end. These were relatively early days of such an preoccupation, but he took to it like a duck to water, or rather perhaps a spider from Mars extending its web. And Melissa was a thing of the past, never again mentioned. He was now dating, indeed seriously so, someone quite else: Iman. He brought her to the studio to meet us. This tall model was simply mesmerising: quietly dignified and very beautiful, but her most arresting feature was a skin that seemed to glow and radiate light.

We were in the presence, had we but known it, of David's 'Dark Star'. The woman he was to marry, who would have his child, and stay with him until the end.

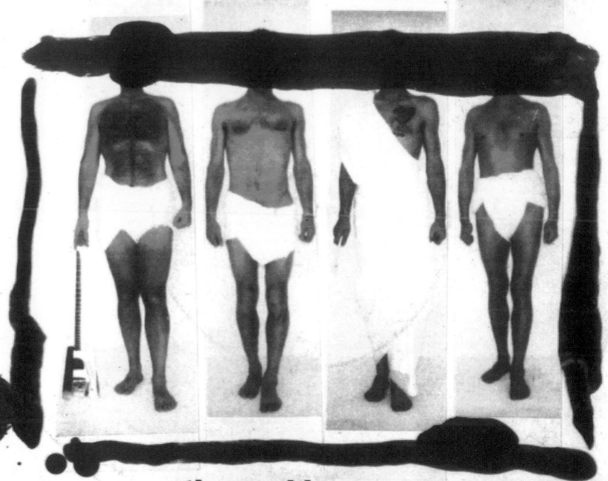

Tin Machine

tin machine

baby universal
(new mix)

Edward Bell

Circus

Before I could escape the cloying irksomeness of Los Angeles, there was one last thing I wished to do. I wanted to photograph the band in Kouros stance, naked but tastefully draped and, of course, headless (what fun for the fans to guess which nearly naked body belonged to Bowie!). This actually could have been done in any back yard, but an out-of-town studio had been booked along with a vast circus. There were security, make up and wardrobe; there were stylists, hairdressers and caterers and record company officials and all had their respective assistants; there was also an amazement of wives, girlfriends and children, all belonging to the band.

Closing one's mind to all that, it was magical once again to be photographing Bowie with his totally focused attention, interpretation, anticipation. He worked with one, giving of himself all the time. Even though his head was not to appear, he had his beard shaved off, discreet make up applied and hair coiffed. I couldn't have asked for a more gratifying and exhilarating finale. In the end, I reflected, Bowie and I had found the rapport that David and I simply hadn't achieved.

When it was time to leave there were hugs again, band included, and promises to reconvene when they toured to take London by storm.

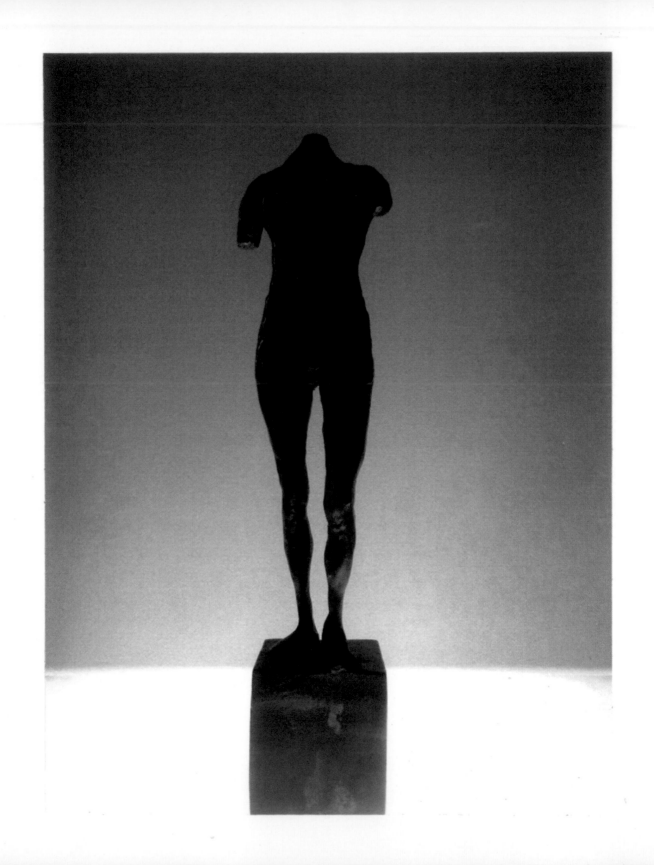

SA 900
7864
AAD

BIEM STEMRA
℗1991 Tin Machine
©1991 Tin Machine

tin machine
tin machine II

828 272-2

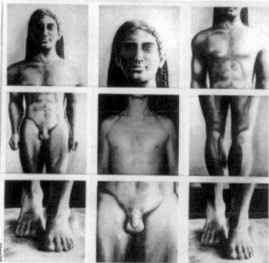

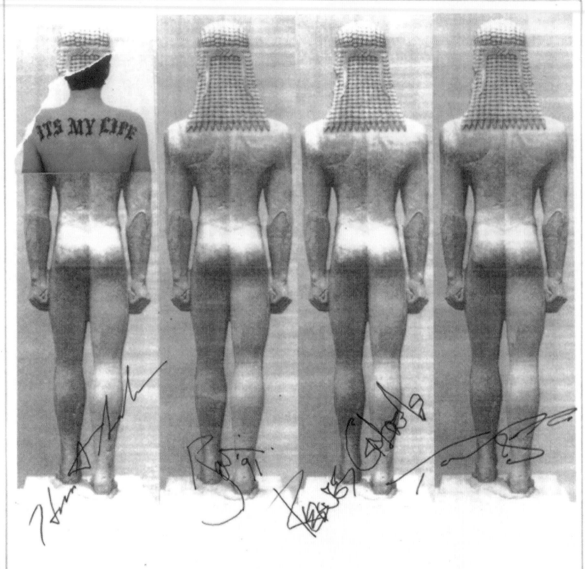

ORIGINAL

Sketch, Back cover "Tin Machine" Album

Mechanical Fault

Not without some relief I flew back home and set about finishing the artwork. I sent it to New York – job done – sat back in anticipation of release date and tour; completely unaware that Tin Machine was badly malfunctioning, off course and heading for an inevitable nose-dive.

When he climbed into the Tin Machine with his team of three other musical astronauts, he set out to circumnavigate the world and discover new ones... to universal applause. Instead, deafened by their own angry sound, David and the band found themselves out of time with their audience.

'Tin Machine II' the album was greeted with something less than enthusiasm. So forget the concept of his anonymity within a band; the record company panicked: stickers were printed and stuck on the album and single sleeve to inform those who hadn't noticed that David Bowie *was Tin Machine*.

Worse was the censoring of the album cover. 'Middle America' was evidently badly offended by the full nudity of ancient Greek sculpture. In a hasty reprint, the offending genitalia were obliterated, as if bludgeoned with a sledgehammer.

When playing in London, Bowie and the band never did drop round for a cup of tea as promised. They gritted their teeth and performed to sparse audiences, with Bowie sporting a T-shirt proclaiming, 'Fuck You: I'm Tin Machine'.

Nor, as promised, did they turn up to the private view of the exhibition of Tin Machine artwork. Instead I got an aggressive phone call the night before the private view from Bowie's solicitor, forbidding me to show my work. They owned the copyright sure enough, but I could, by law, if I so wished, bury, burn, give away or sell the originals. The solicitor, of course, knew this, backed down and pleaded that he was only following orders from above.

The exhibition went ahead as planned and I heard no more.

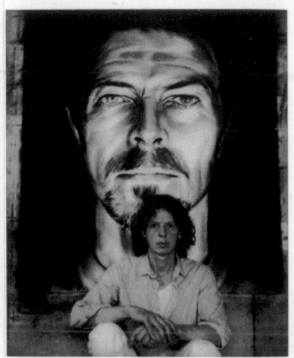
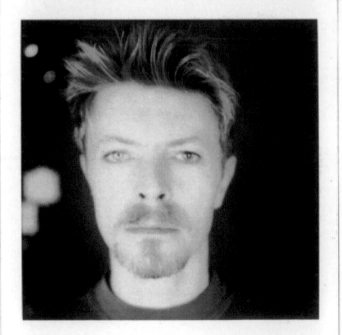

Absolution

It was some form of exorcism for me to paint an enormous head of David as he appeared in my mind's eye, coloured by the recent past. 'The windows of the soul', daring one to stare into an abyss beyond humanity, stark and ruthless.

Months passed– I sent a photo of the portrait with a letter to David which started, 'We are both a pain in the arse, but I forgive you.'

All in all, take it or leave it, I felt that this may quite possibly have been enough to finish our association for good.

On the contrary, David rang, all sweetness and light, wanting to buy the portrait. Wonderful, I thought, but on the other hand, why? It seemed that he must have distanced himself from recent history and rationalized that what he was projecting then was just another persona, an act of no consequence.[5] Either way, I supposed that I had been forgiven, and although I never actually saw him again, he never entirely stopped stirring the embers of our relationship.

Embers

Although I turn a blind eye to the world of computers, somehow David and I never completely lost touch. Back in 1980 he had passed me a 'secret' address where letters would reach him; so over the years I would occasionally write or send images. It was like putting messages in a bottle to drift eternally upon the ocean, or beaming thought patterns into the ether, but it transpired that they always found their destination. I never got a letter back. Instead he would, completely out of the blue, telephone. Years even might pass, then I'd be shopping at Tesco, or digging a vegetable patch on the West coast of Ireland, or sitting on a Welsh hilltop painting the sky, when the mobile would ring:

'David'

'David who?... Oh, *that* David.'

[5] Some unkind souls have suggested he'd 'done a Winston Churchill' and acquired the portrait in order to burn it, or, at the very least, 'done a Dorian Gray' and hidden it in his attic.

These random communications with the real world paradoxically high-lighted his detachment from it – in effect, his absence of ability to empathise.

I can't say what prompted any call in particular, although in general, one supposed him a lonely person, with very few real intimates (if any), who simply had to fill every gap in time; the calls came often in the middle of the night.

Several times, he assured me solemnly that he would make an effort to come to a forthcoming private view of my work, although he never turned up. On one occasion when I was living in Ireland, he rang and told me the news of Michael Hutchence's death, though offering no clue as to why he mentioned it, before quickly changing the subject. What, he wanted to know, was the countryside like where I was living, because he was thinking of buying a castle in the area?

I, too, had to maintain a certain degree of detachment, and indeed to want and expect nothing of him; the paradox will always remain, that if David Bowie had not been David Bowie, then David Bowie and I could have been friends.

Last Call

The last call came somewhere around 2013 whilst I was living in a small hilltop caravan in the wilds of Wales; Bowie wished to resurrect the 'Glamour' image (1980) to use as a poster for a film he was currently working on. It all seemed a long time ago, and far, far away.

I never did find out what happened to the project; and never heard from him again.

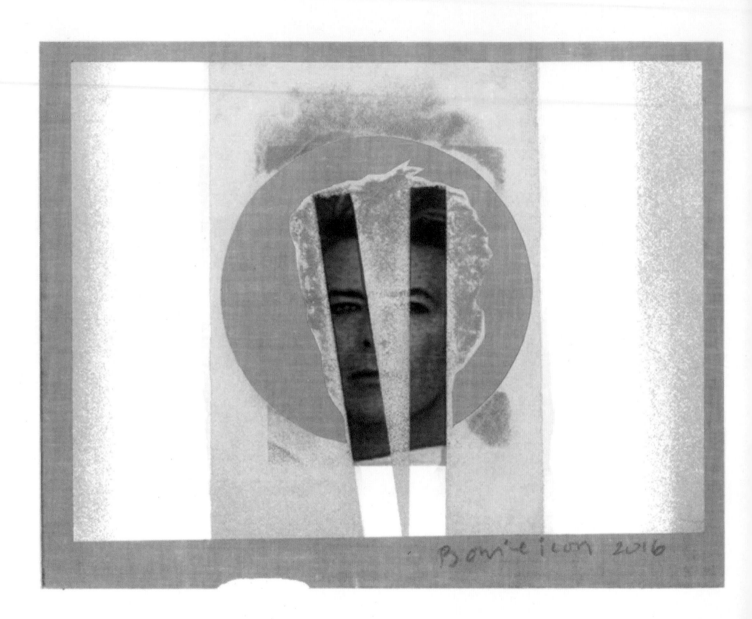

Bowie icon 2016

Post Mortem

Bowie was a crosser of boundaries, a breaker of rules, but if you wanted to be within his orbit, you had to keep *his* rules. The best time to know him was before the release of an album, when he was focused on the job and those best able to help him. He became anxious, accessible and humble whilst awaiting the outcome of his latest throw of the dice: will it secure his throne, engender an escalation of adulation, open the blank vaults to accommodate an avalanche?

When living together in Berlin, Iggy Pop was ostracised for raiding Bowie's fridge, but Bowie himself was a plunderer on a grand scale of other people's creative ideas. He managed to do this with surgical charm; 'please' and 'thank you' were words he found unnecessary.

The Dark Star would entice into his orbit all whose light he needed, then drift off into other orbits of plunder in a vain effort to satisfy a black hole of intellectual, creative hunger.

Inconclusive Conclusion

One forgives everything, when blinded by an all-encompassing multi-faceted brilliance; but, on the other hand, can a friendship thereby be formed by ignoring the reality that we are each a flawed being, reflecting a kaleidoscope of individual foibles, friction and contradiction that serve to shape such a pearl? If ambiguity is found to permeate the tenor of this account, it merely highlights the extent of the participants' inclination towards such characteristics.

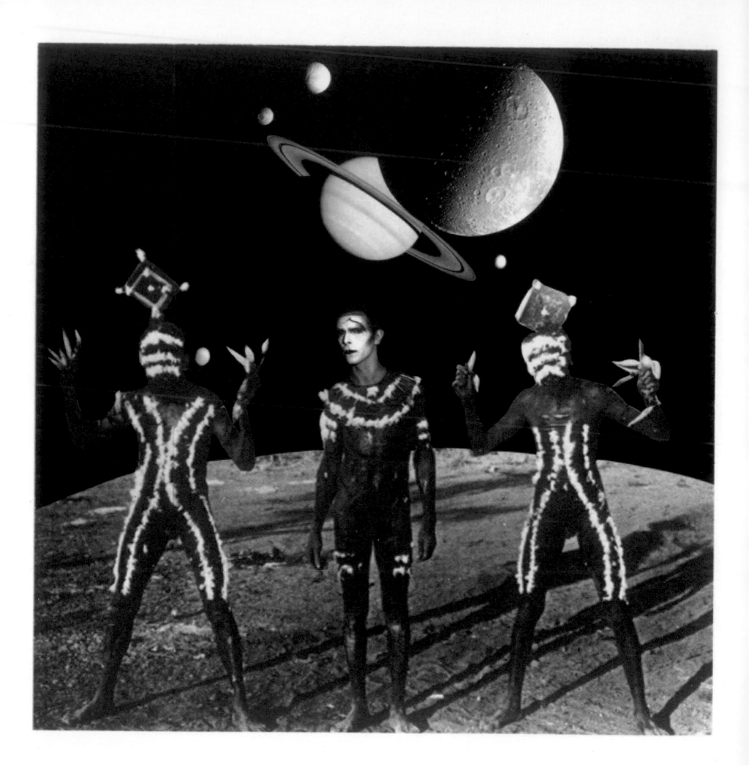

Musings : Telling Tales ?

Stories I have heard– sources anonymous– make of them what you will.

'Hermione was the only girlfriend ever to jilt him– he never got over it; the very next day he dyed his hair, red like hers.'

'He used to stuff all his cash under the mattress until I introduced him to the concept of having a bank account.'

'I was thrown out of his party, apparently because I looked uncannily like him...'

'... And there were Jagger and Bowie in a corner at Tramps snogging each other...'

'We were renting a villa next door to him in Mustique, and one night he insisted on driving us round the island in his jeep... turned out he was blind drunk, and kept accelerating to the cliff's edge... then breaking just short of plunging over...'

'I was with my partner, he was with his, but when he looked at me across the dance floor, and our eyes met, the attraction was electric, mutual and instant. He held my gaze and mouthed... 'Later'.'

Poor girl; he, now dead, and she, an old woman, but still, I'm sure, somewhere in her heart... waiting.

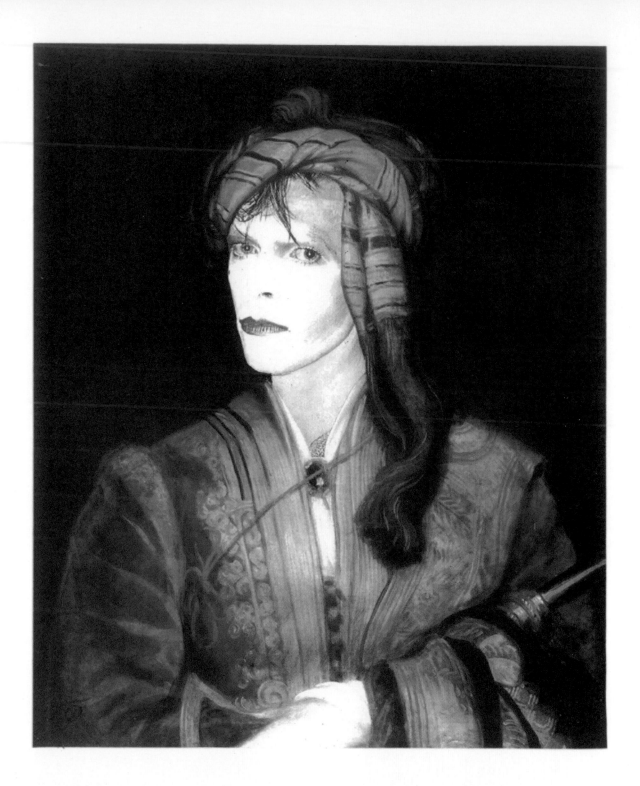

More musing : Byron/Bowie

Conversations with David were wide ranging, probing, searching and stimulating. Other individuals of originality and style were discussed, but never do I remember a mention of Lord Byron; which looking back seems strange. Byron/Bowie had much in common: two exceptional beings, who trapped the zeitgeist of their times, who became figureheads of fame and fascination. Thus the following can be seen as a musing on notes for a discussion that we never had.

Lord Byron, pin-up poet of the 18th Century. Influences of the The Thin White Duke? Or the pleated shirt worn in *Black Star* video?

Life style, flamboyant dress, flouting of convention. Each dared to be himself, exploring every aspect, careless of censure.

Admiration for Napoleon/Hitler.

Byron/Bowie, both in their own way, wished to conquer the world; armed with soaring talent and almost feminine beauty, they flaunted their bisexuality to seduce each and every man and woman.

They wholly identified with the characters of their creation: Corsair, Don Juan/Ziggy, Major Tom.

Byron had a crippled leg, whilst Bowie is quoted as saying, 'I always look for parts with an emotional or physical limp.'

Both flirted with the idea of retiring to a monastery.

Both recognised the importance of editing, manipulating and enhancing whatever fantasy should contribute to their immortality.

Both lived and died in exile.

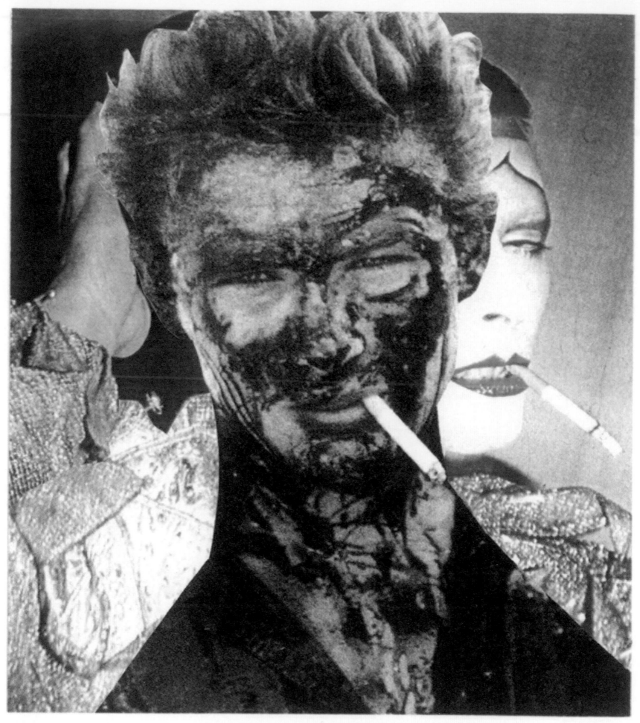

James Byron Dean
not quite as seen in the film "Giant". 1955

Berlioz concerning Byron wrote, 'the extraordinary nature of the man, at once ruthless and of extreme tenderness, generous hearted and without pity' (perhaps attributes necessary for anyone of vaulting ambition).

In the final analysis, however, Bowie could not be described as 'Mad, bad and dangerous to know.'

In 1938, one hundred and fourteen years after Byron's death, an excuse was found to open his coffin and examine the embalmed remains. Although his complexion seemed 'somewhat sallow', it was remarked that he was instantly recognisable; also that his sexual organ displayed 'quite abnormal development'.

Perhaps Bowie was wise to opt for a prompt cremation.

The adjectives 'Byronic' and 'Bowiesque' have permeated our culture and will long resonate in the collective consciousness.

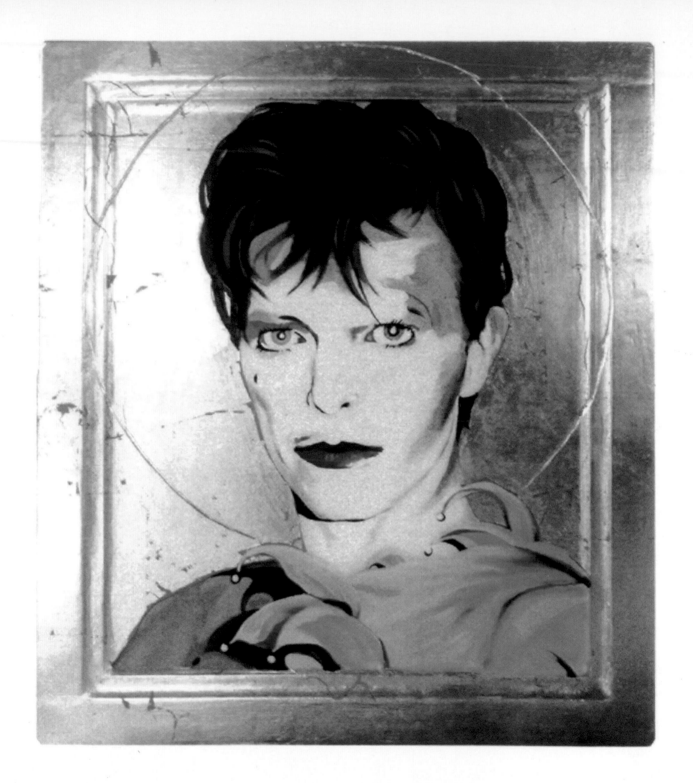

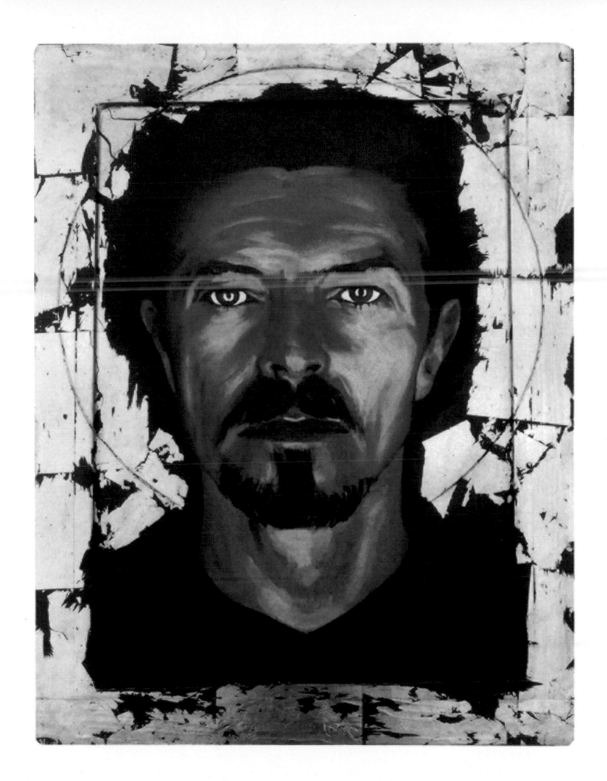

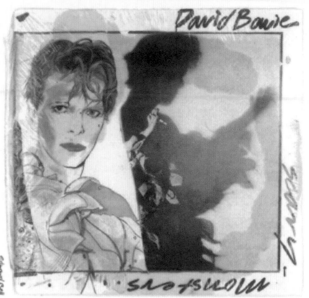

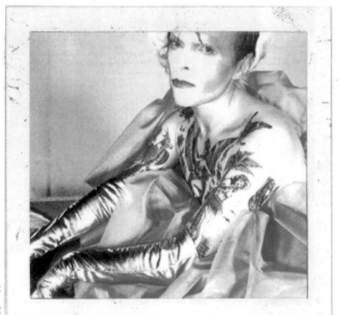

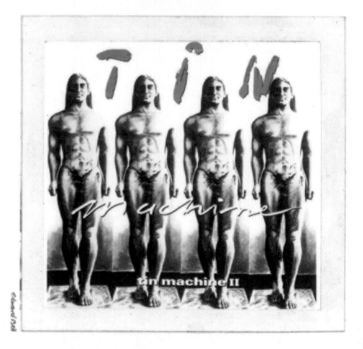

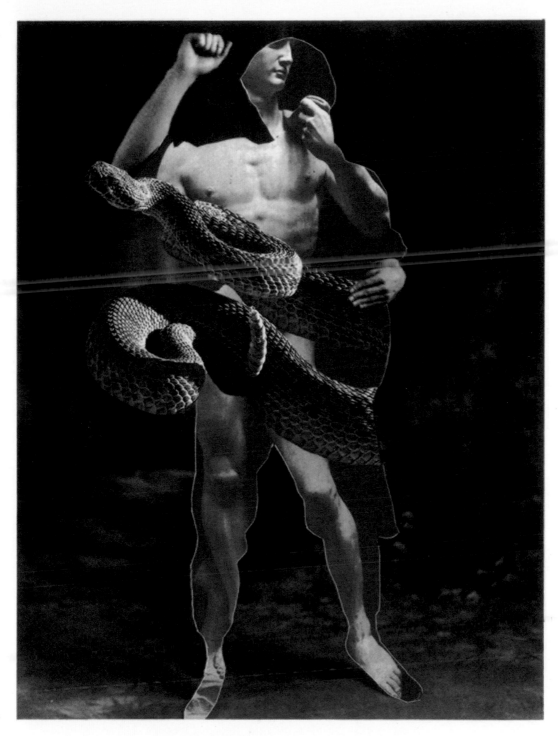

David wrestling with his demons

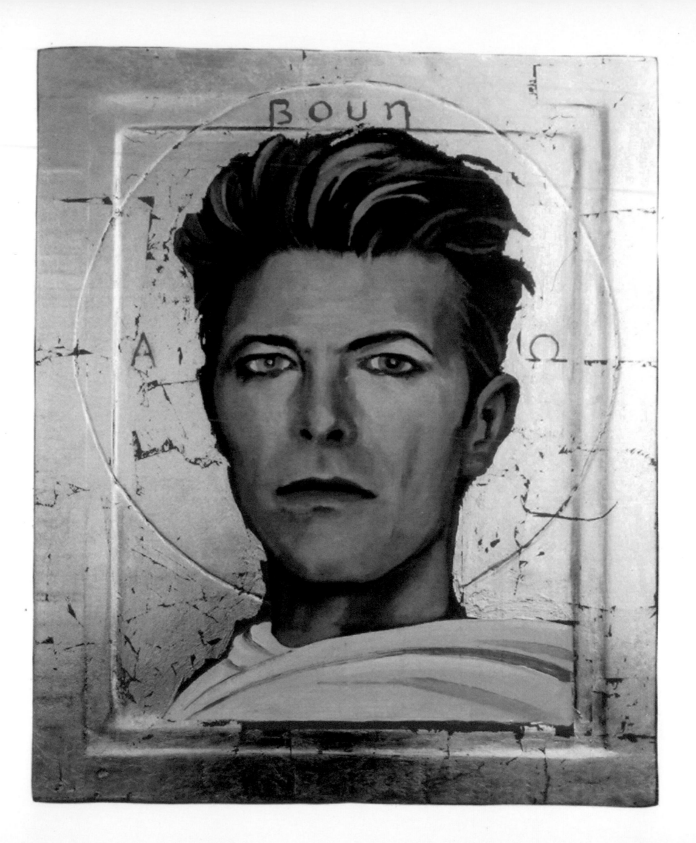

Further Musings: Bowie Icon

Bowie was circus; the whole circus. He was clown, tight rope walker, lion tamer, snake charmer, acrobat and ringmaster. He shed the binding chains, could ride a horse standing, eat fire and swallow swords. He dazzled in costume, never stood still. He charmed and enchanted, flayed and enslaved. Hypnotised, they followed in his footsteps; mesmerised, they danced to his tune. He blinded, he deafened and left all speechless to define

When young, we prayed to America: the New World, Land of Plenty, Land of the Free, where everything was big and big was good, the role models were more exciting. The 50s faded, the 60s swung and the 70s had sagged under the weight of disillusion; tired of gazing at the miasma creeping across 'the pond' we were ready to turn to home-grown cultural phenomena. The Beatles had stepped into the breach and stormed the establishment's rotting edifice: other bands followed; we lacked only a king to rival Elvis. Bowie, though, had vision, ambition and the courage to learn from his mistakes. He was endlessly inventive and highly quirky; qualities prized and nurtured this side of the Atlantic. He didn't immediately grab the pinnacle– he ducked and dived, invented and reinvented, sidestepped and rose simply because he couldn't be boxed or pinned down. He portrayed different versions of a new strange Adam; expulsion from The Garden of Eden ever pending, but never executed, for always being one step ahead, he would snuff out his creation and reincarnate. He was profligate with his muses, for they were legion, to be entertained, drained and discarded at will. He didn't slay his demons but charmed them, carried them with him and put them to work on his behalf. He rummaged in the wardrobe one last time; death yet another costume change. His final death – on stage as ever – was outrageous, horrifying, impertinent, paradoxical; it was daring, it was blasphemy for a being to suggest the invention of death. Finally he had led the way to a place where even the most devoted of fans could not immediately follow or even believe in. He left them hungry.

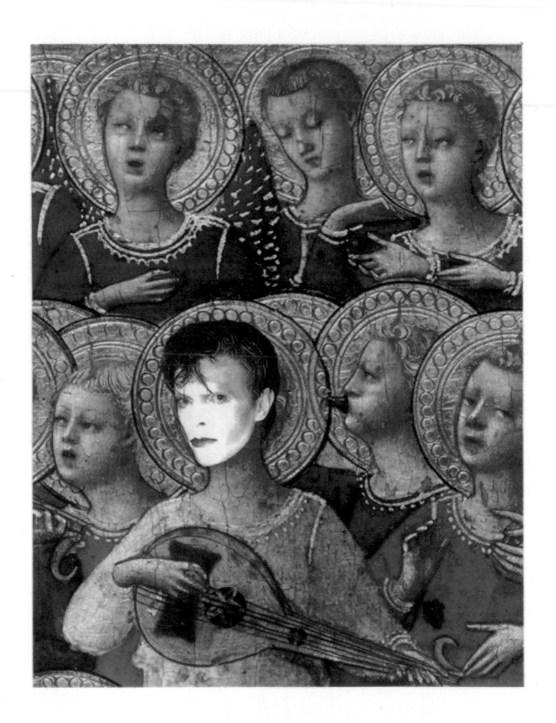

Long before he died Bowie had become a symbol: the word derives from the Greek, meaning 'to draw together'. A symbol for estranged youth to identify with and venerate as they would a Saviour.

He can now be resurrected: he is ready to be revered as an icon.

An icon is more than a symbol. It is a distillation: the essence summed up in one ageless timeless image. Icons have been described as 'making present a particular saint or mystery', or more simply as 'a door'. A door that worshippers can enter by meditating upon and merging with the image beheld, to thereby become beautiful in their own image.

The silent painting speaks: it sings, and will fill the faithful with music... Bowie icon. But perhaps whilst Bowie awaits initiation, monitoring the editing, whitewashing, gilding and highlighting of his image, David shall be wistfully casting an eye towards the 'Pearly Gates', anxious to join the queue, maybe to have a cozy chat with Terry Wogan or Motorhead's Lemmy.

Whatever the final judgement, for all those whose lives were touched by the living man, however briefly, lightly, remotely, the flame of remembrance shall never be quenched.

Long Live David Bowie
Rest in peace David Jones

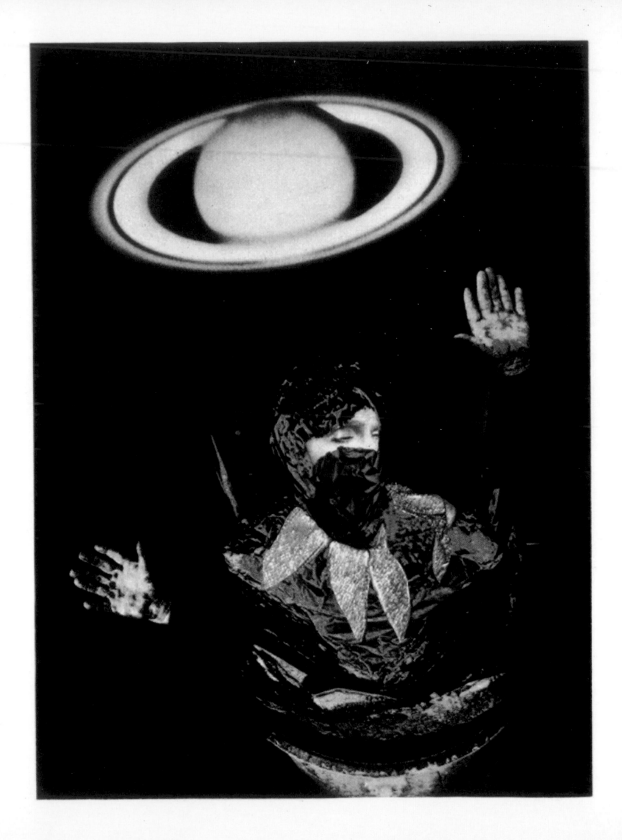

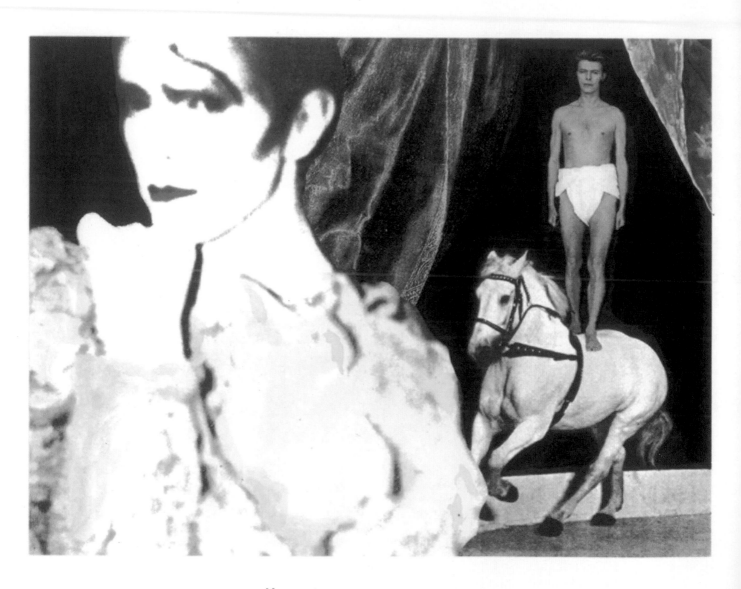

Magnificent balancing act:
Maverick ringmaster / star performer

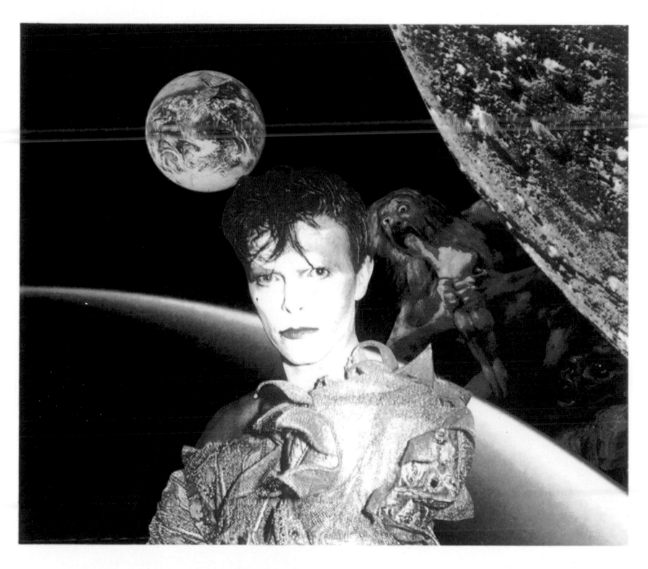

Scary monsters in the skies
Outwitted by a clown disguise

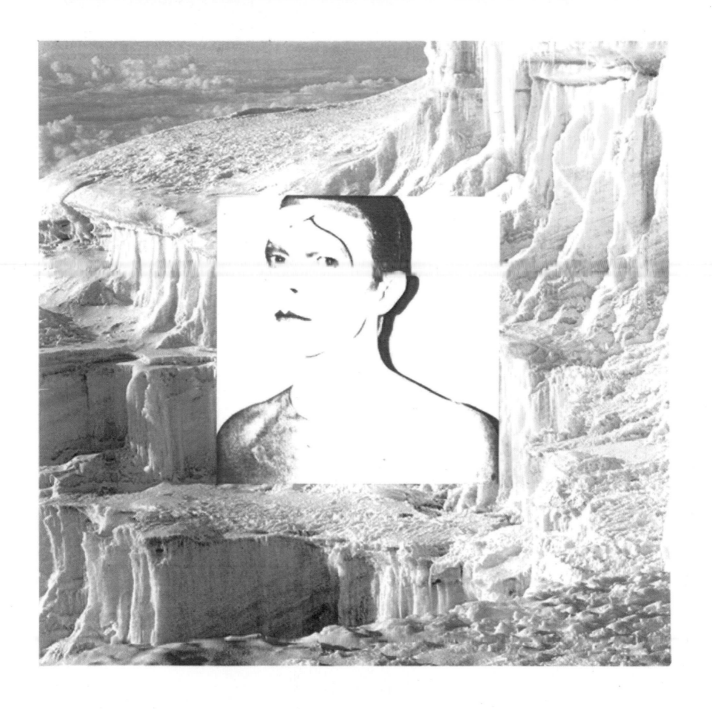

Acclimatised to the chill of high altitude

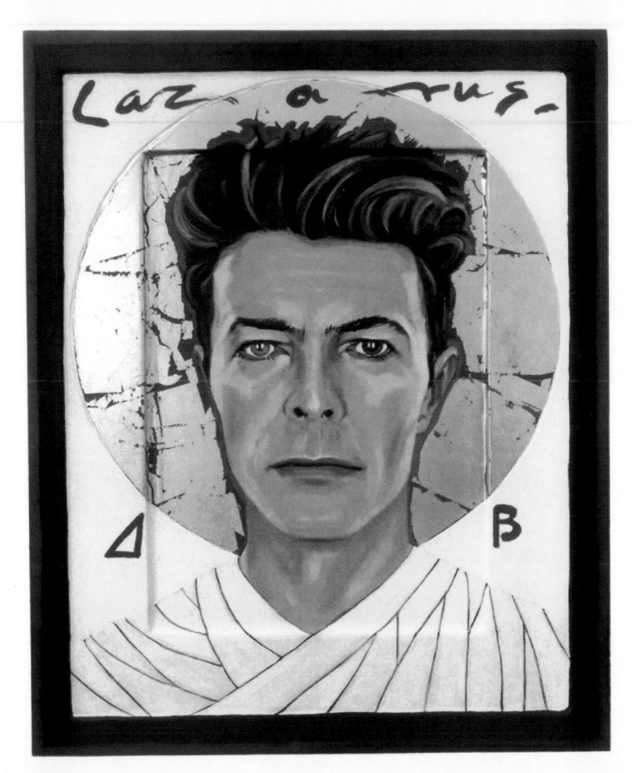

Captions

All illustrations and photographs by Edward Bell;
copyright of same, (except album covers and single sleeves).

Thank you to....

Christine and the chaps at
St Leonards Press for their
patience and expertise,

Peter Burden for his early
encouragement and guidance,

Ian Strathcarron and all at Unicorn
for an enjoyable working relationship,

and Michael Bell: ever supportive,
never judgemental.

Published in 2017 by
Unicorn,
an imprint of Unicorn Publishing Group
101 Wardour Street
London
W1F 0UG
www.unicornpress.org

ISBN 978-1-910787-62-5
10 9 8 7 6 5 4 3 2 1

Printed in India by Imprint Press